Margarine Modelling

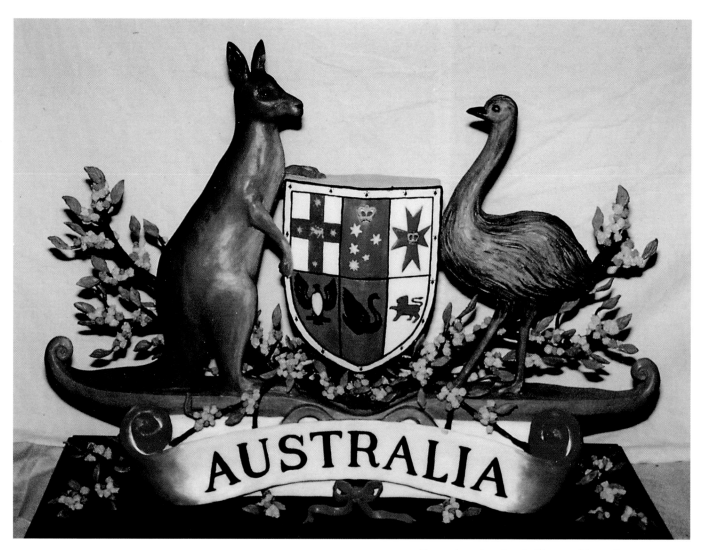

Showpiece for the Culinary Olympics

Margarine Modelling

by Jean and George Hill

Hospitality Press

Melbourne

Hospitality Press Pty Ltd
38 Riddell Parade
P.O. Box 426
Elsternwick
Victoria 3185
Australia

First published 1988

National Library of Australia
Cataloguing-in-publication data:

Hill, Jean, 1942-
 Margarine modelling.
 Includes index.
 ISBN 1 86250 406 7

 1. Margarine. 2. Cookery (Garnishes). 3. Table
 setting and decoration. I. Hill, George, 1942-
 II. Title.

642'.8

Illustrated by Jean Hill
Designed by Louise Laverack and Mandy Carson
Typeset by Dead Set Publishing & Information Services Pty Ltd, Melbourne
Produced by Island Graphics Pty Ltd, Richmond, Vic.
Printed in Singapore
Published by Hospitality Press Pty Ltd, Melbourne

HOSPITALITY is a trademark of Hospitality Press Pty Ltd

Contents

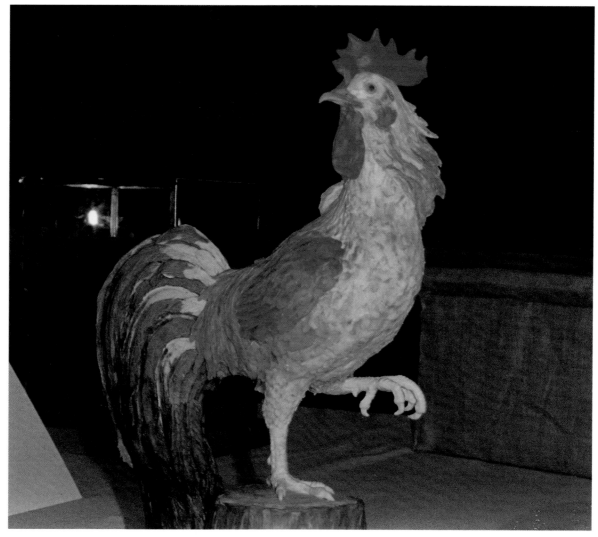

Display centrepiece: Rooster (see pages 110-1)

Acknowledgements

Without the help and support of many friends and organizations we could not have produced this book. In particular we would like to thank the following:

E.O.I. (Edible Oil Industries) Pty Ltd for advice on brands of margarine suitable for modelling available in countries other than Australia and for a very generous donation towards the cost of reproducing the colour photographs.

The Williams Division of Morton Thiokol Limited for information on their food colours and their international availability.

Walter A. Granger Pty Limited, general representative in Australia of Walt Disney Productions, for permission to reproduce photographs of models of copyright characters from Walt Disney films.

The Australasian Guild of Professional Cooks for providing us the challenge of frequent invitations to exhibit our models at competitions and exhibitions organized by the Guild over many years.

Claudio Magris, the well-known Melbourne chef, for his valuable advice. It was his skill at margarine modelling which first inspired us to try to design and make our own models.

Gail and Ernst Stuhler for commissioning challenging models from us for display in their restaurant, and for actively promoting our work.

To all the caterers of Melbourne who have supported us in our modelling work, especially John Fahey, David Payne, O'Brien Catering, and Unger Catering.

David Cunningham for his hard work editing the typescript, and for his belief in the book which has made its publication a reality.

Jean and George Hill
Melbourne, May 1987

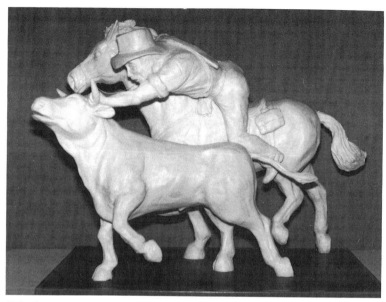

Display centrepiece: Bulldogging

Introduction

This book is designed to show those interested in the art of food presentation the various steps and techniques used in the preparation, display and storage of models made from margarine or butter fat.

It shows by means of simple examples and illustrations how to select, plan, frame, make, present and store margarine sculptures for use as food decorations suitable for any catering occasion.

The use of ornaments to decorate the table is as old as the banquet itself. While over the years, for reasons of hygiene, convenience or cost, the styles and materials used have changed, the intent of expressing the chef's artistic personality on the table in a positive way has not. Chefs have always strived to make their tables as elegant and artistic as possible. While concentrating upon taste, they also take great care to achieve excellence in presentation.

Chefs have always realised that they can attain renown by studying, practising, and becoming masters in one or other of the materials used to enhance food presentation, but the style of buffet decoration and

presentation has dramatically changed to reflect both a changing clientele and a new cost-consciousness in the kitchen. Preparations like the old-fashioned chaudfroid have been replaced by more economical methods of presentation which are nevertheless quite as artistically satisfying and effective as the creations of the classically skilful chefs who spent hours labouring over a single showpiece.

Today's chefs are far more aware of the high price of labour, but they realize that the presentation of food is as important as it always was. Modern buffet presentation therefore tends to rely on decorations which are inexpensive to prepare, relatively quick to make and present effectively on the table, and which last a long time.

The techniques described in this book can be generally applied to butter or margarine fats. However, there are differences between the characteristics of margarine and butter and they are not always equally suitable for modelling.

Many different kinds of materials are used by chefs to create artistic table decorations. Traditionally popular substances have been butter, chocolate, vegetables, ice, pastillage, rice, salt, shells, and sugar. Modern methods of refining and processing animal and vegetable fats have added margarine to this extensive list. Margarine is

now among the most popular mediums from which sculptures are created for food decoration. Margarine is relatively inexpensive, readily available, needs no special preparation, is an easy substance to learn to master, and has an exceptionally good shelf life.

Butter models are usually smaller than margarine models and are intended to be decorative pieces that can also be consumed. They never have any sort of frame or base and are usually formed in a mould rather than being sculpted or made with the hands. Butter models are served with the main dish or on a side plate as an accompaniment. Butter is only suitable for small models. They are made to simple patterns requiring a minimum of handling, which must, for hygienic reasons, be kept to a minimum.

Margarine models on the other hand are designed and made to be displayed purely as an art form and are not meant to be eaten. Margarine models are only intended to enhance the surrounding food and show off the artistic skills of the chef.

The industrial cooking margarine used for modelling has a higher melting point and is much more elastic and pliable at room temperature than butter. Unless the model is definitely to be consumed by the customer there is no practical advantage in

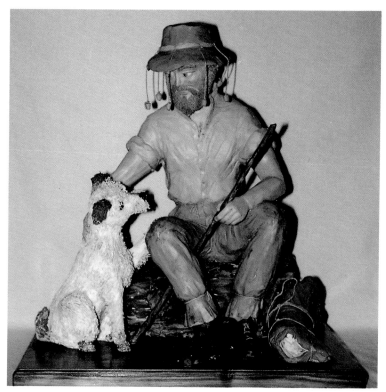

Showpiece: Swagman and his dog (see pages 140-1)

using butter for modelling. In this book, therefore, the emphasis is on margarine.

The chapters follow the various stages in the preparation of a basic fat sculpture in a natural sequential order. The final chapters include detailed plans and instructions for making and presenting both simple and advanced sculptures.

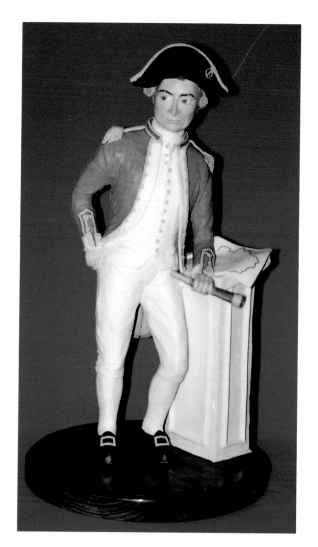

Display centrepiece: Captain Cook

Display centrepiece: Alice in Wonderland
© *Disney*

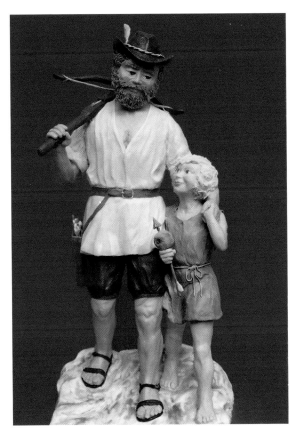

Showpiece: William Tell

The ideas in this book are intended to make the reader aware of the variety of ways in which margarine or butter sculpture can be used to enhance food presentation. Not all the ideas suit all establishments, or all occasions. The reader must be imaginative and innovative, prepared to adapt and to recognize when and where the different models can be used to best advantage, within the constraints of time and cost.

Margarines

History

Margarine was first made by a French chemist called Mège-Mouries in 1869 in response to a prize offered by the Emperor Napoleon III to the first person to develop a cheap artificial butter for use by the Armed Forces and the poorer classes.

The first margarine was made by heating beef tallow and separating from it a soft fat called 'oleo' by chemical and physical means. The oleo was blended with milk and water and then cooled with ice water to produce a 'margarine'.

The name margarine came from the pearl-like crystals seen under the microscope. These are called margarites, from *margaron*, the Greek word for pearl.

Modern margarine is made of a variety of animal and vegetable fats. These are refined, blended, deodorized, and mixed with skim milk, salt, and edible emulsifiers. The blending of the animal tallow and vegetable fats determines the plasticity of the margarine; the greater the proportion of the hard fat called 'stearin', the harder and more plastic the margarine will be.

Types of margarine

There are three main types of margarine:

1. Eating polyunsaturated margarine, which is made principally (80 per cent) of vegetable oils from safflower seeds, sun flower seeds, soybeans, or cotton seed.
2. Eating non-polyunsaturated margarine made from either vegetable or animal fats.
3. Cooking margarine, which is made with not less than 72 per cent animal fat. There are soft and hard varieties of cooking margarine.

Margarine for modelling

The harder and more plastic a margarine is, the better it is for modelling. Hard cooking margarine is therefore used.

In Australia we recommend the use of Pastrex or Hard Cake cooking margarine, but provided they are hard and plastic other brands and types can be substituted successfully.

Brands of margarine recommended for use in Canada, Japan, the United Kingdom,

and the U.S.A. are noted in Appendix 1—Tools and Materials.

Cooking margarine is an excellent medium to work with.

It has all the qualities of a good modelling clay, with the advantage that it will not dry out. When it is not being used it is solid and quite hard, but the heat of the fingers gives it a pliable, highly elastic texture so that it is easy to mould into any shape.

The advantages of margarine

Margarine is an ideal medium for sculpture. It has all the advantages and none of the disadvantages of more traditional food decorations:

1 Margarine will not dry or crack like pastillage, and so the features of a model can be removed and remodelled until a satisfactory result is achieved.
2 Unlike ice, margarine will not melt if kept at normal temperatures, so that a model will last for months, not hours.
3 The texture of margarine does not change like pulled sugar, so no special display cabinet or drying-out facilities are required.
4 Margarine does not set like chocolate, so the chef can work slowly on a model, setting it aside at busy times of the day.

Problems

The only real problem from which margarine suffers as a medium is dust. It shows every speck of dust, and it will (it seems) even attract dirt. The problem can be overcome by following two simple rules:

1 Always work in a spotlessly clean area, and on the cleanest possible surface.
2 When not working on a model, or when storing or transporting it, cover it with a fine, clean cloth.

Summary

1 There are many types of margarine made from various mixtures of animal and vegetable fats.
2 Hard cooking margarine is best for modelling—see Appendix 1: Tools and Materials, under 'Margarine' for the recommended varieties in different countries.
3 Margarine has great advantages over other traditional mediums for food decoration; in particular it is easily-worked and it is economical because of its long shelf life.
4 The only serious problem with margarine is the risk of damage by dust.

Selecting the model

This section consists of photographs of margarine models made by the authors for a variety of places and occasions. It is intended to give you a clear idea of the range of the medium and how margarine sculptures can enhance displays of all kinds of food.

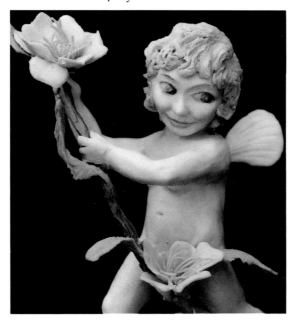

Cupid. An ideal model to go with canapés

Display centrepiece: 'Welcome to wine and dance'

Butter model for a cheese platter

Plate centrepiece to enhance petits fours

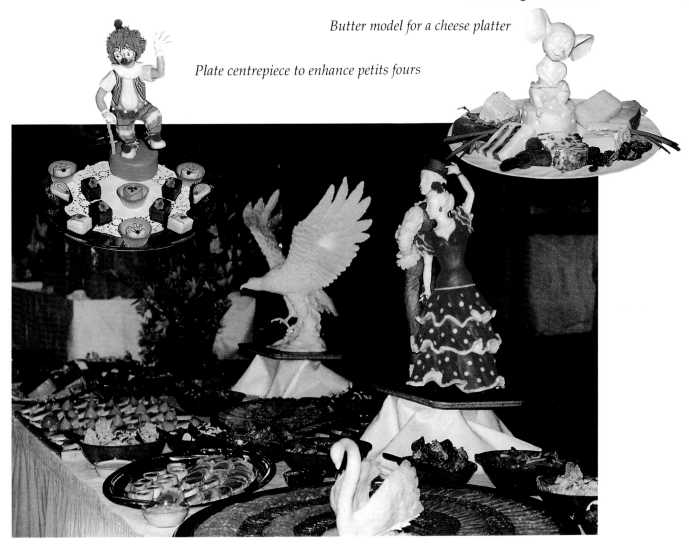

Margarine models displayed on a buffet table

The reception or foyer

A platter of canapés

Canapés should set the mood for what is to follow. They are often served to newly-arrived guests in the foyer before the main part of a function begins. A platter of canapés can be much improved when it is decorated by a small margarine or butter sculpture.

The choice of margarine or butter depends on what sort of canapés are being served. When only decoration is needed margarine is better, but with some types of canapés where butter is a recognized accompaniment only models made of butter are acceptable.

The entrance to the dining room

Any type of catering establishment—restaurant, hotel, function centre, or anywhere else people meet to enjoy a meal—can benefit by having a margarine sculpture at the entrance to the dining room.

If it is to be admired and discussed by the guests, the sculpture must be well-executed, prominently displayed, and it should complement the theme of the function or its surroundings.

Once the sculpture has captured the attention of the guests, it should, by demonstrating the artistic skill of the chef, fill them with high expectations that there will be a fine meal to follow.

The dining room table

Both butter and margarine can be used for decorative purposes on dining room tables, the choice depending mainly on whether or not the pieces are to be eaten.

The butter dish

Small modelled shapes may be presented in the butter dish. As these are meant to be eaten they should always be made of butter and not of modelling margarine. From the plain and simple butter curl to the complex but graceful butter rose, the effort taken to

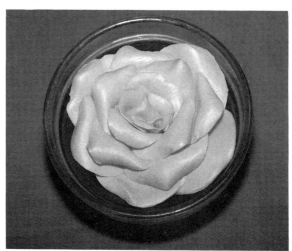

Butter rose

present more than just a square of butter shows that the chef cares about the way food is presented.

A table centrepiece

Small carvings made from margarine and used as the centrepieces for individual tables may accompany or even replace the traditional flower or candle arrangements. Care must be taken to make sure that the models are not so high or bulky that guests cannot see each other properly across the table.

Models should be placed on glass, silver, or the restaurant's own china so that they are pleasingly but discretely displayed.

The cheese platter

A cheese platter can be transformed into a lavish presentation by the inclusion of an appropriate butter model.

As butter is regarded as one of the usual accompaniments to cheese never use margarine for models on the cheese platter.

The petits fours plate

An innovative use of margarine carvings (which the traditionalist chef will not like) is to present small sculptures on a plate or silver platter surrounded by petits fours. This novel way of presenting an artistic finale to a meal is becoming commercially popular.

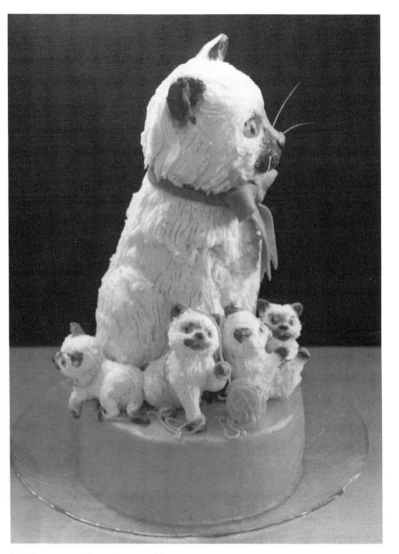

Table centrepiece: Cat and kittens

To make sure that the model does not topple over when the plate is being served the model is fixed to the plate, usually through a doily, which has been placed on a little melted margarine. Do not allow the petits fours and the margarine model to come into contact with one another.

The buffet table

Models on buffet platters

Buffets lend themselves naturally to impressive displays of food. The various platters of beautifully-arranged food will of course always remain the main attraction of any buffet, but their effect can be enhanced by the use of decorative pieces which lend height to the display and emphasize either the theme of the occasion or of particular dishes.

As chefs seek new methods of presentation to stimulate their guests' appetites, the use of margarine sculptures directly on the buffet platter is gaining much popularity. Models used in this way must suit the food they decorate. For example, a small bull's head on a beef platter is very fitting. The model, set in the corner of the platter surrounded by precisely cut slices of beef suitably garnished and glazed, offers an alternative and modern method of presentation.

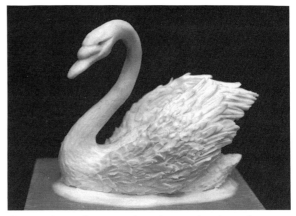
Swan. A good centrepiece for a selection of canapés

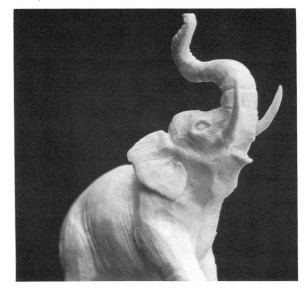
Elephant for the buffet table

Display centrepieces (*pièces montées*)

Decorative pieces (often of inedible ingredients) made to ornament the centre of the buffet table have always been popular in the better class of dining rooms.

In the early seventies ice carvings became very popular for this purpose. Chefs realized that ice was readily available and quite inexpensive and that, after some practice, they could carve impressive and appropriate centrepieces from it.

More recently carving and modelling industrial cooking margarine has become popular as chefs have become aware that it has two major advantages over ice. First, margarine models can be worked on and remodelled until perfection is achieved and they can easily be repaired if they are damaged. Secondly margarine models last much longer than ice carvings, and can be used over and over again. This makes them much more economical to prepare than ice carvings.

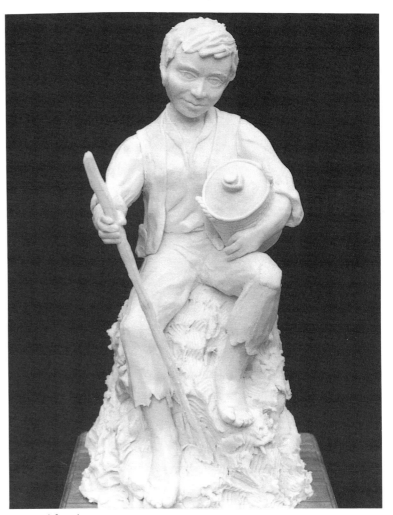

Boy with wine

Summary

1 Margarine models can be displayed anywhere food is served, but the display must suit the occasion and the food.
2 Margarine should be used in preference to butter unless the models are to be eaten.
3 The most popular settings for models are:
 Reception or foyer (with canapés)
 Entrance to the dining room
 Table decoration (butter dish, table centrepiece, cheese platter, or with petits fours)
 Buffet table (buffet platters, or display centrepiece).
4 Care must be taken that models are fixed firmly enough to survive without toppling over.
5 Margarine has many advantages over ice as a medium for display centrepieces.

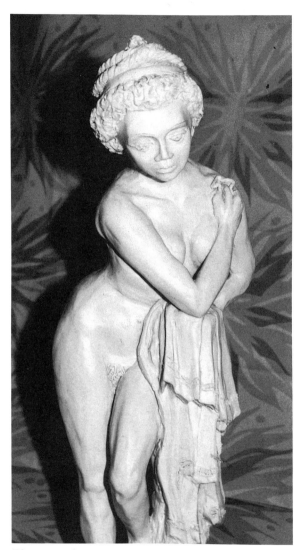

Figure sculpture

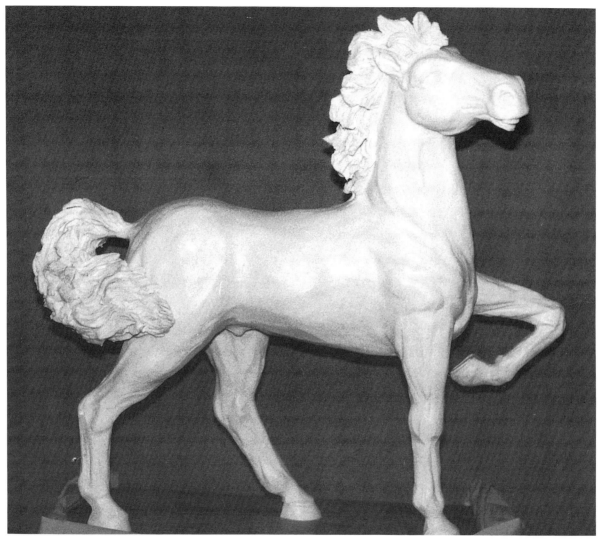

Showpiece: Horse

Planning, research and design

Planning

The most important factor in the making of a successful margarine model, especially a model with an original design, is the care taken in planning it.

If the model is not being made for a special occasion like Christmas or a racing carnival, or there is no reason for a specific theme, for example a company logo, choose a subject which will be suitable for a large variety of occasions. The more often a model can be used the more economical it will be.

Beginners should only attempt simple designs, and the level of difficulty should be gradually increased as experience is gained. Don't try to be too adventurous as a simple, well-executed model will always be more effective than a complicated one badly made.

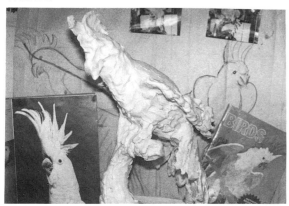

Good planning is a must

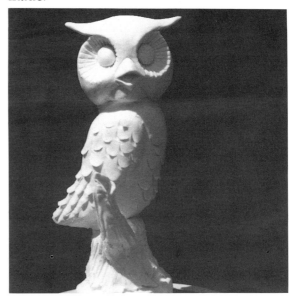

Start with simple designs

Inexperienced modellers will find it very helpful if they base their models on small plastic or china ornaments which they can copy in margarine. This avoids any need for original research, and all that is required is to draw the model in the size required.

Even if your design is original, it may be helpful to use small models in your research as it is difficult to visualize the correct placing of complicated features such as muscles from photographs or pictures as these can never show the subject from all angles.

Research

Research is important no matter how experienced a modeller you are, or how well you know your subject. Further study will always discover some new aspect which will add life and character to the piece being made.

Public libraries are very helpful for research as pictures of all kinds can be found there—from classical sculptures to comic-book characters. Children's books, catalogues and magazines can be collected as useful sources of ideas and for reference.

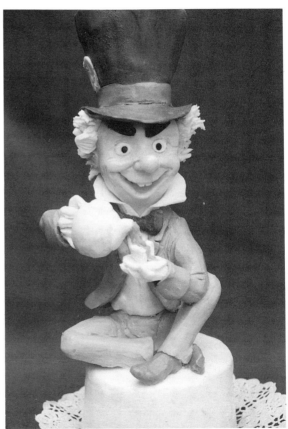

The Mad Hatter
© Disney

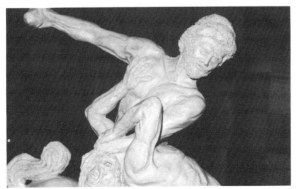

Classical sculpture

Simplification

One of the secrets of a successful model is to simplify the design, but to emphasize the distinguishing features of the subject.

For example, when making an eagle, it is impossible to get each feather perfect, but an eagle has unique characteristics which give the bird its special character: the hooked beak, fierce eyes, powerful wings and sharp talons. Concentrate on these. Similarly, if making a swan, emphasize, even exaggerate, its gracefulness; the long, slender neck, the way it holds its wings. Even though your swan may be stylized and simplified it must be immediately recognizable—and not end up an ugly duckling.

Good research will help to identify the special qualities of the subjects chosen and so help the modeller to produce effective and striking models.

Human subjects must be researched with particular care as mistakes are immediately obvious, and the pose chosen must be a practical one. If the pose is an action movement, try it yourself in front of a mirror, or get someone to pose for you so that you can note the general body movement.

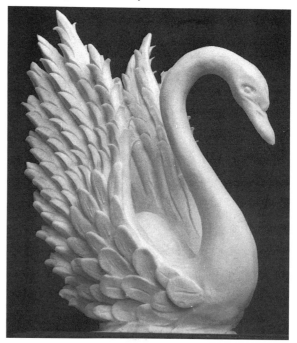

A graceful swan

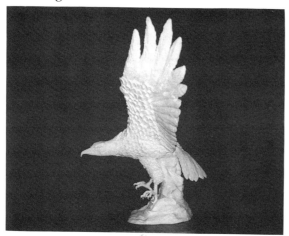

Eagle

If the figure has a specialized action, make sure you get it right. For example, if modelling a golfer, discover exactly how a golfer stands, places his feet, swings his body, and holds his hands on the club. If a horse and jockey are to be made, find out how a jockey sits on a horse, how that is different from the way ordinary riders sit; make sure that the clothes and saddle are correct.

The essential and distinguishing characteristics of a subject can only be found by careful investigation and observation. Research will identify the features and peculiarities which give a subject its particular individuality and character, the features which must be emphasized to make an effective model in spite of simplification of the details.

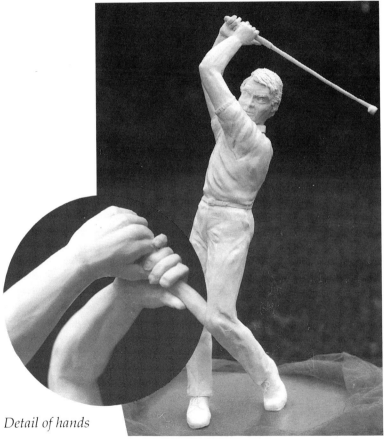

Detail of hands

Golfer

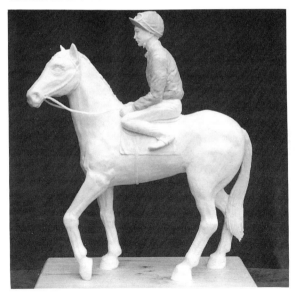

Note how the jockey sits

Stability

Stability is a very important design consideration. If your model is to be moved around a lot then plan accordingly. If a model has a solid wide base, a mermaid for example, then it will travel better than one of a figure on two legs which will tend to sway and crack at the narrow parts. Whether or not the model is likely to be moved frequently try to have at least three supporting structures to give it stability. A flamingo on one leg may look very attractive as a drawing but it will not be at all practicable as a margarine sculpture.

Rough models

It may be difficult to visualize from drawings what more complicated designs will look like in three dimensions. It is often useful to make a small, rough model to help with the design and the placement of the frame, and to give a clear three-dimensional idea of how the finished subject will look.

It is important to remember that all models are three-dimensional objects and that the design has to be considered from all angles.

The drawings

Once the subject has been planned and all the research materials have been gathered together it is time to start the drawings. The

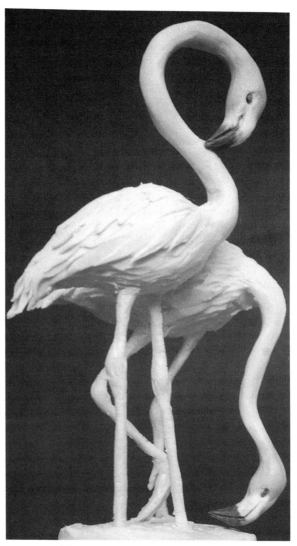

Use a stable design

more time you spend on the drawings and getting them absolutely right the less time you will have to spend on the model itself.

The drawing is the modeller's plan, like the plan a builder needs to build a house. It is there to be used. It should not be a complex masterpiece, but it must be a well thought-out guide to the form and shape of the subject of the model.

The first step in preparing a drawing is to analyse the subject carefully. We are all used to looking at things without analysing what we see. Try drawing a horse without a reference at hand. Everyone has seen horses often enough, but unless you have really analysed what you have been seeing it is extremely difficult to draw one. Only careful observation and analysis gives you a clear idea of the actual shape and relevant proportions of the subject. Use your research material for this analysis.

Design

Start with thumb-nail sketches. These are small rough drawings to experiment with ideas. Do a whole series of them, treating the subject from different angles and in different positions. This will help you to decide the best way of presenting the model and to choose the pose or action which will make the most of the subject at the same time as being a very practicable design.

Once the best pose has been selected the chosen sketch or sketches are enlarged to the actual size of the model you are going to make. Both side and front views should be drawn (unless you are making a two-dimensional plaque). The drawing need not include all the details but its shape and the placing of the important features must be accurate as the whole design depends on it.

Butcher's paper, which is available in most kitchens, is ideal for the full-size drawings. Use two sheets, each large enough to cover the subject from one side or point of view, or one sheet if it is large enough to take both views.

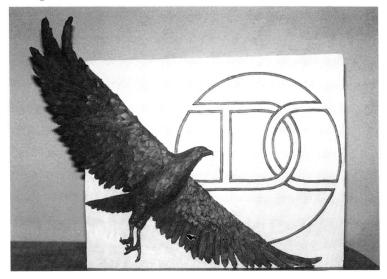

A relief model only needs one drawing

The grid

To make your full-size drawings you may find it helpful to use a grid. This technique enables you to enlarge a picture, model or your own small sketch to the actual size of the planned model.

A simple method of making a grid is to take a piece of paper which is the correct size, fold it in half, then half again, both vertically and horizontally, creasing heavily.

This will mark the paper into sixteen equal squares or rectangles. Open the paper and draw along the creases and you have your grid.

A smaller grid of exactly the same proportions can also be made to cover the picture or photograph which is to be enlarged. It should be just large enough to cover the picture. Make sure that the relative height and width are the same for both the large and the small grids.

You can draw a grid directly onto the picture you want to copy or, if you do not want to mark the original photo or design by drawing on it, you can draw the grid first onto tracing paper, greaseproof paper or clear plastic with a felt pen. It is then easier, by referring to the grid and treating each square as an individual drawing, to transfer the main features of the small design onto the full-sized paper.

If you are enlarging a small model, measure its quarter, half, and three-quarter points both vertically and horizontally, and then draw them in on your grid paper. This will ensure that you get the proportions correct. Do this for both front and side views.

Once you are satisfied that you have got the main outlines and features correctly placed on your grid drawings, you can draw them in boldly with a felt pen.

Two drawings (or more) are needed because they make it easier to turn a two-dimensional design into a three-dimensional model. For example, if you are designing a model of a horse (fig. 1), start with the side view, and then use the side view to determine (by referring to the grid) the height of the main features from a front view. Then draw the front view, showing how the head and neck are turned, by how much and in which direction.

The frame and the base

When your drawings have been finished mark in the position of the frame using another colour. Your drawing can then be used as a template for bending the frame.

The drawing can also be used to determine the size and shape of the base and to measure where the frame must be attached to the base. Gauge this by using the drawing as a reference to visualize the model on

the base. Do this first from the front view and then turn to the drawing of the side view noting the exact points where you mean to attach the frame to the base, making sure that the model will be well centred on the base and will stand steadily. Mark on the base the points where the frame will be attached to it (fig. 2).

When you have bent the frame to the shape you require, but before you finally drill the holes to attach it to the base, place the frame onto these marks and make sure it

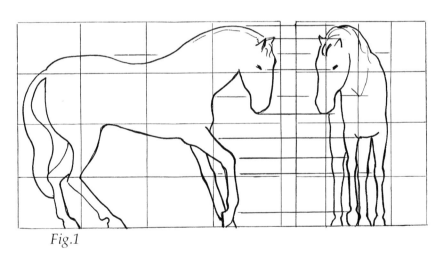

Fig.1

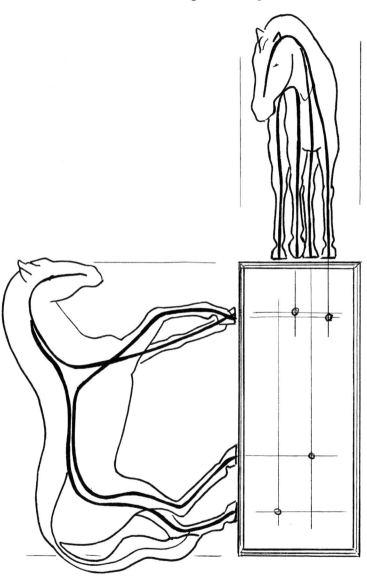

Fig.2

matches the frame you have drawn in the second colour within the outline of the model to make quite certain it is right from both points of view. Make any adjustments necessary and, after a final check, drill the holes for the frame in the base and attach it.

Summary

1 Plan what to make—and keep within your capabilities.

2 Research the subject of your model.

3 Choose from a range of sketches and possible designs the one which best suits your subject—and one which is perfectly practicable.

4 Make an actual size drawing of both the front and side views.

5 Draw in the frame and mark on the base where the supporting structure will be positioned.

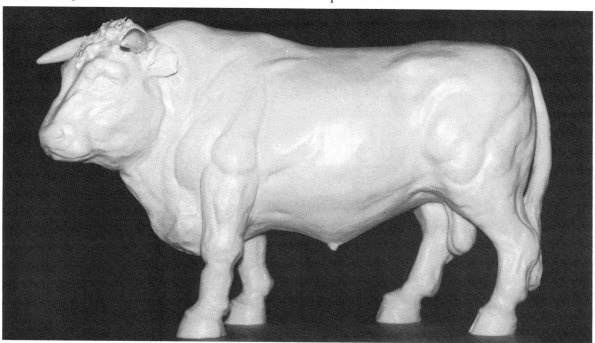

A bull would suit a function at an agricultural show. The muscles need research

Bases and frames

Supporting the frame

There are two basic supports in a margarine model: the base and the frame. The base supports the frame and the weight of the model, and should either be large enough or heavy enough to be very steady. The frame supports the margarine which is built up on it to form the model.

Good bases and frames are absolutely essential for successful models, and the effort and thought that is put into them will pay dividends. This applies especially to the frame which must be strong and steady enough to support the contours of the finished model without any evidence of the framework showing.

Bases

Types of Base

The base must be firm, steady enough to support the model, and heavy enough to prevent the model from being knocked over accidentally. This is especially important if the model is going to be moved around the establishment frequently or be transported from place to place, by a caterer for example.

We recommend two types of bases: wooden bases and plaster bases. A wooden base should be selected when the stand needs to be large and light, and a plaster base is best used when you need a small heavy support for your model.

Round wooden base, polished and with a good grain

Making wooden bases

Wooden bases should be made from plank at least 20 mm thick. The width and breadth of the plank depend on the size of the model. As a general rule a wooden base should have a surface area larger than the perimeter of the planned sculpture.

The choice of the wood to use for the base depends on the quality of the model and the impression you wish to create. You can use chipboard or pine or any other readily available wood provided it will stand firm and enhance the total appearance of the model.

The base should be painted, or stained and polished, or stained and coated with clear Estapol. If you are using a chipboard base it is best to laminex it. Whether you paint, stain, or laminex your base depends on the wood you have chosen and the particular model you are making, but the base should complement the sculpture in quality and presentation. For example, if you want a stained and polished base, choose a wood with a good grain which will be brought out by the stain and shown off to advantage. Do not forget to pay attention to the outer edge of the base, and to make sure it is attractively finished. Plastic tape can be used to finish the edges, or you can get the timber yard to rout or shape them for you.

Making plaster bases

Heavy, and usually small, bases are made from plaster of Paris. Plaster powder is mixed with water to a smooth paste and then set in a suitable mould to form a heavy sturdy platform that will support the margarine model. Any suitable smooth glass or plastic container can be used as a mould.

If you intend to use a plaster base the frame must be made first as it is fixed in the base when the plaster sets. How to make frames is described in detail below. They are made from mild steel rods bent into the right shape.

Select a mould of the right size for your model, making sure that it is very smooth on the inside so that the plaster can be removed easily when it has set.

Sprinkle the plaster powder onto cold water and then stir it until you have a smooth paste. Take care that there are no air bubbles in the paste. Pour the plaster mixture into the mould and immediately suspend the frame in the mixture and hold it suspended in position until the plaster has set. The plaster should be allowed to set for at least twenty-four hours before you remove the mould or begin working on the model.

Plaster bases, unlike wooden bases, are completely covered with margarine to disguise them when the model is made.

Fig.1
Bend the wire into shape to make the frame

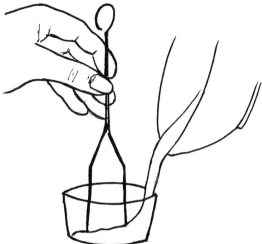

Fig.3
Add the plaster to the mould with the main frame held in place

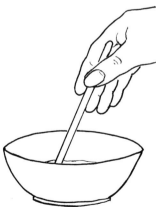

Fig.2
Slowly mix the plaster

Fig.4
When the plaster has set remove the frame from the mould

Frames

Types of frame

There are three basic materials used to make frames:

wooden dowels
styrofoam
metal rods

Wood dowel framing

Wooden dowelling can be bought from hardware stores or timber yards in sizes from 10 mm to 30 mm, the size depending on the size of the model and the strength of the frame required. Cut the dowel to the right length with a wood saw and, if you are using a wooden base, drill a hole in it to fit the dowel. Glue the dowel firmly to the base.

Wooden dowel frames are suitable for large and bulky or very straight models. It is usually better to use metal rods for models with curved contours.

Styrofoam

Styrofoam frames have two advantages: they are light and models using them are relatively cheap to make because not so much margarine has to be used. Although styrofoam is the most expensive framing material, it costs only half as much as margarine on a volume basis.

Styrofoam is bought in large blocks. Sketch the model directly onto the styrofoam and cut it out with a sharp knife, as nearly in the shape of the model as possible. Attach this 'sculptured' styrofoam frame to a wooden base by pinning it with a metal rod.

Styrofoam frames are particularly useful when you expect to make the same model again as the old margarine can easily be stripped off, the frame washed, and a new model moulded onto it.

The disadvantages are that styrofoam is extremely messy to carve, and that by itself it cannot be made to support the very fine features of a model.

Metal rod framing

Mild steel rods make excellent frames for margarine models of any size. The rods are strong enough to support the substantial weight of a large piece of margarine and they have the great advantage that they can be bent into whatever shape is required for the model. And because the rods are strong and quite thin the frame can be extended to the extreme tips of the model.

Steel rods, called 'rounds', can be bought from general engineering suppliers. Rounds come in many different sizes from 5 mm to 50 mm diameter and up to three metres long. The only sizes used in margarine

modelling are 5, 6, and 8 mm diameter rounds, in whatever lengths are needed. The choice of size depends on the strength

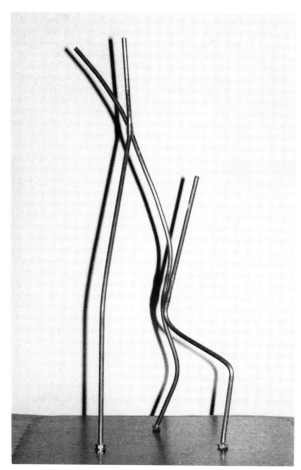

Basic metal rod frame

the frame will need to support the model you are making.

Making metal rod frames

Select a rod in the size your model requires and cut it to the right length using heavy duty bolt cutters. Hold the rod in a vice and bend it into shape following the drawing of your design and the contours of the model. Cut a thread in the end of the rod which is to be attached to the base using a stock-and-die cast.

Drill a tight-fitting hole in the base to suit the diameter of the rod. Counter-sink the bottom of the base to allow a washer and a nut to be recessed into it. Then bolt the rod firmly to the base with a washer and nut on both sides of the base.

When the main rod frame has been bent into shape and firmly bolted to the base, you can add thinner wire supports for extra strength or to hold other features of the model. The best wire for this is florist's wire. It is attached to the main frame by white parafilm tape (florist's tape). This tape stretches and is wound tightly round the wire and the frame to join them together. It can also be used to cover the frame to prevent rusting or any discolouring of the margarine by its metal support.

Fig.6
The rod is bolted to the base

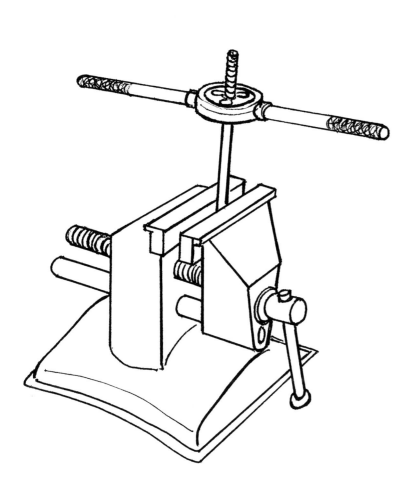

Fig.5
Cut a thread on the rod with a stock-and-die cast

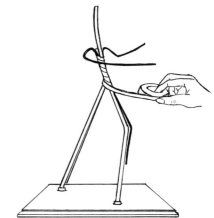

Fig.7
Attach the secondary framework to the main
frame with florist's tape

Styrofoam can also be used with a metal rod frame to take up bulk and to make the model lighter. It is added after the rod frame has been bolted to the base, but before any thin wire supports have been taped on.

We strongly recommend metal rod frames for most margarine models. The rods are versatile, quick to use and inexpensive. Any shape or size of frame can be made quickly, and by the addition of styrofoam blocks the frames can be kept reasonably light. The only drawback is that special equipment is needed to cut and thread the rods.

You have now chosen your subject, prepared your drawings, and made a suitable strong frame and base. You are now ready to begin adding the margarine.

The metal frame is covered with florist's tape

Styrofoam takes up the bulk of the body

Summary

1 Two supports are required for any model: a base and a frame.
2 Bases must be steady and must complement the model.
3 There are two types of base: wooden and plaster.
4 Frames must be strong enough to support the margarine.
5 There are three common types of frame: wooden dowel, styrofoam, and metal rod.
6 Metal rod frames are best for most models, particularly when used in combination with styrofoam and florist's wire.

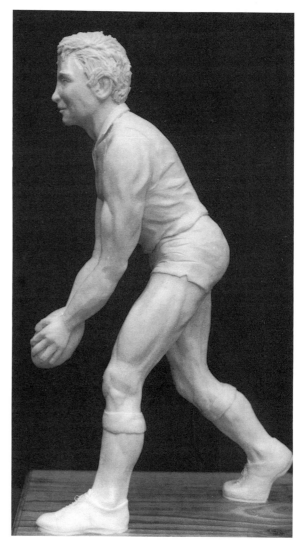

A sporting figure like this needs a solid frame

Making the model

Mise-en-place

Choose a suitable place in which to work, ideally a quiet area away from the main kitchen traffic with a good work bench. Thoroughly clean the bench before starting work as margarine easily attracts any specks of dust or dirt. Choose the knives and tools required (see Section 6 and Appendix 1 'Tools and Materials' for special modelling tools) and place them within easy reach (fig. 1).

Preparing the margarine

If your margarine is in a very large block cut enough into smaller workable pieces to allow for continuity of work. If the margarine is very cold and hard it can be warmed slowly in an oven or put through a microwave on a low heat until it is soft and pliable. This should be no more than 30° Celsius (or 86° Fahrenheit). On no account allow the margarine to overheat and melt, as the consistency will change, causing the

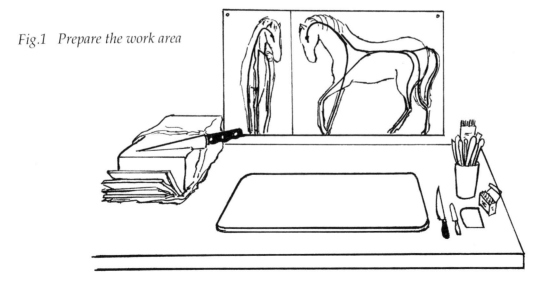

Fig.1 Prepare the work area

texture to become brittle and lumpy when it cools down.

Adding the margarine

Take a piece of margarine, soften it slightly by squashing it between the fingers, and press it firmly onto the frame (fig. 2). Add pieces in this way until the whole frame is well covered. Continue to build up the margarine from the front until the model begins to take shape. Occasionally spread the prepared drawings behind the model to check the model against them or, better still, fix the drawings so that they can be seen at all times and the model can be moved into position in front of them to check the outlines (fig. 3).

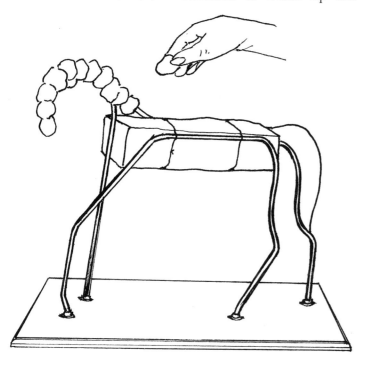

Fig.2
Add small pieces until the frame is covered

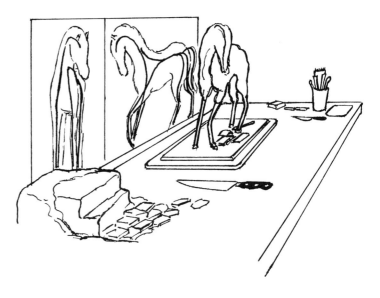

Fig.3
Move into position and compare the outline

Using the drawings as a guide, add and take away the margarine where necessary until the outline of the sculpture begins to take shape. When the front silhouette is right turn the sculpture sideways and repeat the process, checking all the time against your drawing. Once the front and side outlines are right, start working from all round the model, adding small pieces of margarine and packing them down well as you work to make the model firm and to avoid air bubbles and cracking.

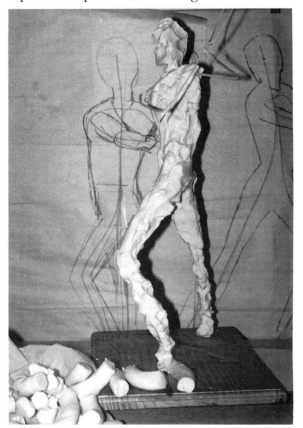

Use the drawing as a guide

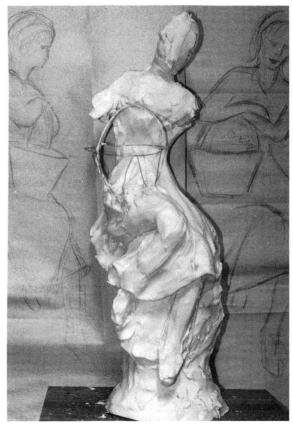

Work from all round the model

Basic shaping

Keep working in this way, constructing the model to match the design, marking out and forming the special features. Be bold at first, exaggerating the lines and angles. Cut firmly into the margarine to develop the shape and character of the model.

Work from all sides and compare the model as it takes shape with your reference material and drawings. When you are satisfied that the design and shape are just as you want them to be it is time to blend in, smooth over and firm up the whole model.

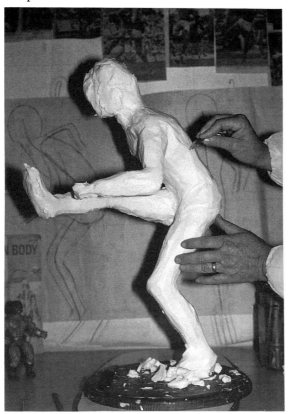

Develop the shape

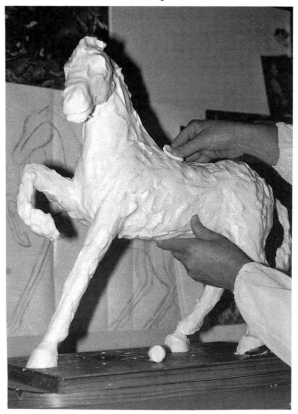

Pack the margarine down solidly

Firming and smoothing the model

There is a variety of tools which can be used for smoothing the model. Choose the one that suits you best, steadily firming up the whole model (fig. 4). Do not give too much attention to any particular detail at this stage. It is most frustrating to spend a quarter of an hour getting an eye perfect only to find that it is not placed quite correctly, and even worse to finish a head in all its details and then to find it is not at the right angle.

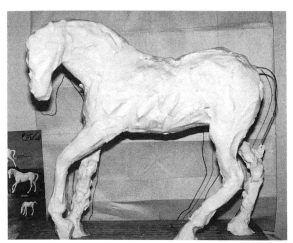

Compare the model with the drawing

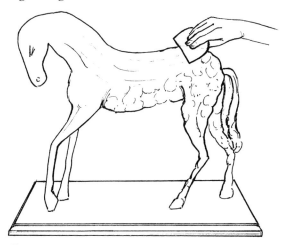

Fig.4
Smooth down the model

Shaping the details

When adding the details work systematically from the top down, or from one end to the other, so that you do not damage or disturb any of the work you have already completed.

Add the details of faces, hands, muscles, and clothes, and the textures and special effects of hair, feathers, fur, etc. necessary for the particular model you are working on.

Sections 6, 7, and 8 will help you master the techniques of modelling details like these. When the details and the textures have been added, and the smooth areas have been rubbed down, check to see if some extra emphasis of detail or texture is needed to add the finishing touches.

Try to plan your model so that it has a variety of surface textures which will add interest by contrasting with each other.

The amount of work put into a model and the level of detail you aim at must of course be decided not only by purely artistic considerations but by the time and money that can be spared for it. No professional chef can ignore the economic factors.

Before starting work on any detail stand back and look at the model with a fresh eye. Be critical—does it have enough character, life and movement? Is it just as you imagined it? Can it be altered to give it the right qualities? There may even be things not foreseen in the original planning which would improve it. Study the model from all sides; compare it again with your reference material.

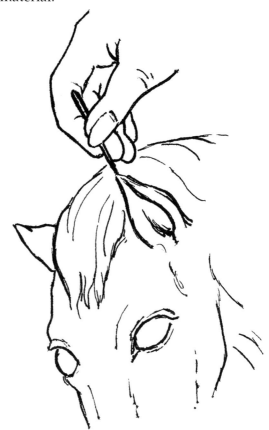

Fig.5
Add the details and reinforce the extremities

Remember that no part of the frame should show when the model is finished, yet every bit of it must be adequately supported. Small extremities where the main frame does not reach should be reinforced while the model is being built up by inserting thin wires, satay sticks or toothpicks into the margarine (fig. 5). Only when you are thoroughly satisfied that the shape is just right, and that the model is solidly constructed, is it time to begin to add the fine details.

The big advantage of margarine over most of the other food mediums used for decoration is that if you don't like what you have done you can dismantle it and start again. Any part of the model can be removed and reworked many times until you are thoroughly satisfied with it. However, if you carefully follow the step-by-step approach, and make sure that each stage is right before moving on to the next, it should be possible to produce a pleasing model without having to do much of the work several times over. Practice will of course make you more skilful so that you can confidently take on more and more ambitious projects.

When your model is finished, or has to be put aside while you work on something else, cover it with a fine cloth to keep the dust off.

Add the details

Summary

1 Prepare the work area.
2 Prepare your tools.
3 Prepare the margarine.
4 Cover the frame with margarine.
5 Build up the margarine to match your drawing of the front outline.
6 Build up the margarine to match the profile drawing.
7 Fill in all round.
8 Pack the margarine down and smooth it.
9 Look at the shape critically and make any necessary changes.
10 Add the details.
11 Apply the finishing touches.
12 Cover the finished model with a fine cloth.

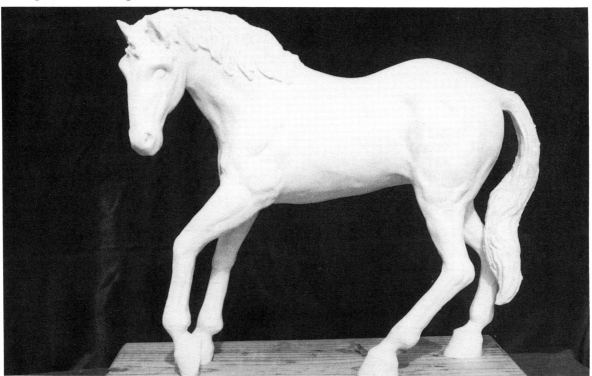

The finished model

Techniques with tools

Modelling tools

A large variety of tools can be used to shape, mould or carve margarine. Specialist clay modelling tools made from wood, metal or plastic can be bought in a variety of shapes and sizes and with round, straight or serrated edges (fig. 1).

Wood or lino-cutting sets are also available and can be a useful extra resource for the margarine modeller. But the beginner will find everything he or she really needs already available in any reasonably well-equipped commercial kitchen.

Knives, spatulas and scrapers

In all commercial kitchens one finds a variety of knives ranging from the large cook's knife to the paring knife. Most of them will be used in the making of a margarine sculpture. For example, the large cook's knife cuts the solid block of margarine into small workable pieces and the paring knife is used to trim surfaces or add detail to the model. Knives with serrated edges are used to mark waves or lines. Spatulas and plastic scrapers are ideal for making large smooth areas.

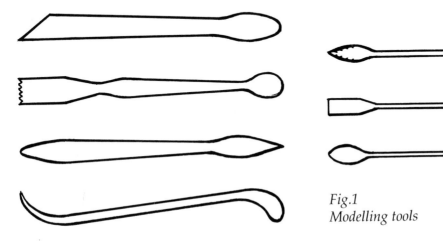

Fig.1
Modelling tools

The satay stick or wooden skewer

One of the simplest tools, yet the most useful and versatile, is the satay stick or wooden meat skewer, especially the very flexible kind. It can, for example, be used to scrape off surplus margarine. Hold the satay stick at either end and bend it to form a slight curve (fig. 2). By using the stick in this way you can easily make smooth round curves and angles.

You can also use the point of a satay stick for cutting and carving, or to produce fine lines and details, and to get into small and inaccessible parts of the model. The blunt end of the stick is good for making straight lines and ridges.

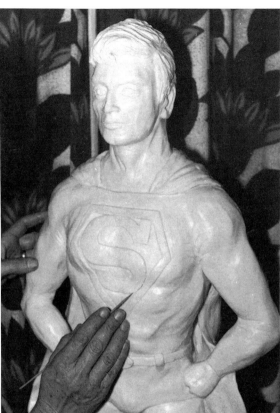

Using a satay stick to add details

Fig.2
Shaping with a satay stick

Toothpicks and cotton buds

Small details, especially details on faces, can be produced with the aid of a toothpick. The kind of toothpick which has ends of two different shapes is especially useful. The pointed and flat ends both lend themselves to a variety of fine work.

Toothpicks can also be wrapped in cotton wool to make cotton buds (or you can buy ready-made cotton buds). If you dip the cotton bud into hot water and gently rub the margarine with it you can create small smooth areas and remove ridges and bumps. You will find this technique particularly useful when working on faces as the hot water makes it easier to form and shape the subtle contours you need.

Parisienne cutters (melon ball cutters)

A range of parisienne cutters in different sizes is useful as they can be used to create a number of different effects. They can be used to make holes or balls. Balls can be cut in half with a warm knife, or a cross slice taken, to make buttons. Whenever uniform circles are required the parisienne cutter is ideal.

Parisienne cutters can also be used to make scales for fish or reptiles or feathers for birds. This is done by using a hot cutter to cut a half circle into the model's surface

and lifting it slightly as the tool is removed, so producing the effect of a scale or feather. The cutter must be hot so that it will pass into and out of the margarine easily and make a clean cut.

Heat the cutter by standing it in a container of boiling water. If you have a large surface to turn into feathers or scales, use two or three cutters, changing tools every few cuts, so that other cutters are heating while one is being used. This will add greatly to the speed and continuity of your work.

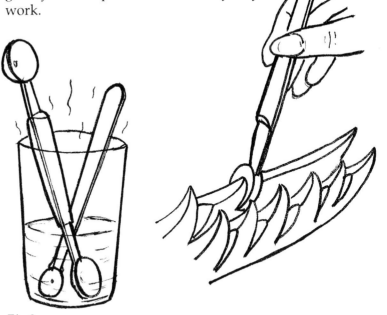

Fig.3
Using the parisienne cutter

Different effects can be obtained by using cutters of different sizes, or by cutting at different angles, as well as by cutting onto surfaces with different textures.

To make the pointed feathers of a bird's wing, model a wing with ridges where the feathers are to be. Cut along the top of these ridges with your parisienne cutter to make the feathers (fig. 3). You can get the effect of a fish's scales or the scales of a mermaid's tail by cutting into a smooth flat surface. With just a little practice and experimentation these effects can soon be mastered.

Garlic crushers

Garlic crushers are very useful kitchen tools, which can be used to make fine strands of margarine. You can get crushers with holes of various sizes to give you strands in different thicknesses. Force the margarine through the crusher to make the strands, and use them either as individual strings or clustered together.

Clusters can be used for all sorts of effects, for example tufts of grass, the stamens of flowers, shaggy hair for a dog, or a ball of wool for a kitten.

To make clusters you squeeze the margarine through the crusher until you have strands of the right length. Then scrape off a cluster of whatever size you want with a pointed tool (fig. 4) and place it in position on the model. If you want the effect of a ball of string you roll up a cluster of long strands.

Delicate single strands have to be handled with great care. Keep a bowl of cold water by you and use it to keep both your hands and your tools wet. Water stops the margarine from sticking and makes it easier to put individual strands in place.

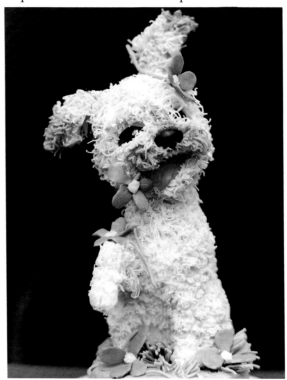

Effects achieved by using a garlic crusher

You can use short, thin individual strands to make eyebrows and even eyelashes, or for jewellery like rings and earrings. Longer strands can be used for necklaces, string or rope, for shoe laces, or to construct the veins of a muscular arm. The technique is to remove the individual strands from the garlic crusher with a wet toothpick and carefully press them into position with another wet toothpick.

Thicker strands can make decorations for dresses, or can be flattened to make ribbons, or bridles and reins for horses.

Two or more strands can be used to make a wider ribbon by placing them side by side and melding them together with a flat-ended tool. Strands can be twisted together to form platted hair, ropes or basket handles.

If you want longer strands, just keep adding margarine and squeezing it through the crusher and you will be able to make strands of any length.

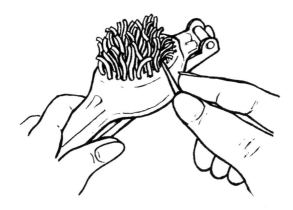

Fig.4
Clusters formed with a garlic crusher

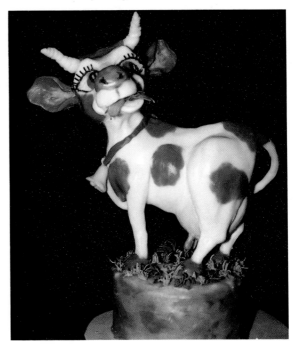

Note the variety of effects achieved by using a garlic crusher

Icing sets

Icing sets can also be used to make long strips and lengths of different shapes.

Cheese slicers

A cheese slicer can be used to take many thin slices of a particular shape straight from a block of margarine. Cut a thick wedge of margarine into the shape you want—a leaf, petal, or ribbon perhaps—and then use the cheese slicer to take slices of the right shape and thickness from the wedge (fig. 5). This is a very quick way of working but care must be taken to keep the slicer very wet as, if it is not wet, it sticks easily.

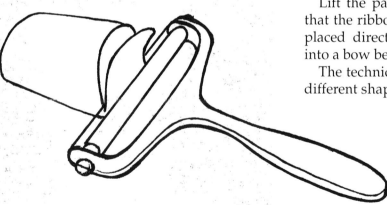

Fig.5
Slices made with a cheese slicer

Paper towels

Many different decorative shapes, ribbons for example, can be made with the help of paper towels. This is the technique:

Take a sheet of kitchen paper towel (the stronger commercial type is best) and two jugs of water, one hot and one cold.

Pour a little cold water onto the paper over the area to be used.

If you are making a ribbon, roll a tube of margarine between your hands to approximately the right length and flatten it onto the wet paper until it is the right thickness. Dip a knife into the hot water and use it to cut the margarine to the width and length of the ribbon you want.

Lift the paper slightly and you will find that the ribbon can be peeled off easily, and placed directly on your model or shaped into a bow before you put it there.

The technique can be used to make many different shapes.

Spread the margarine onto paper towelling (which has first been wetted with cold water) until the margarine is the right thickness and then cut it into any shape you like with a hot knife (fig. 6). You will find this a useful technique for making collars, pockets, and clothes of all kinds, as well as all sorts of flower petals and leaves. Leaves can be given jagged edges and textured with veins before they are lifted from the paper. The blunt end of a satay stick makes a good tool for this kind of detailed work.

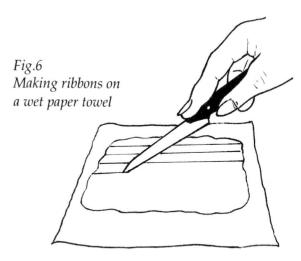

Fig.6
Making ribbons on
a wet paper towel

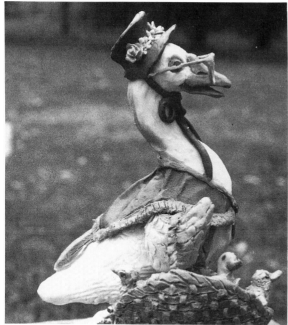

Mother Goose

Cutters

Sets of pastry or biscuit cutters, or aspic cutters, can be used to make fancy shapes. Use the paper towel technique just described, making sure that the cutters, especially small aspic cutters, are dipped in hot water before you use them.

Make the cut quickly so that the margarine does not stick to the inside of the cutter.

You can buy special cutters in the shape of leaves and other things in ceramic shops. These have springs on them to push out the object that has been cut. However, it is probably not worth buying ceramic cutters unless you expect to make a lot of the same shapes as they are quite expensive.

The clay press

If you are going to do a lot of small fancy work it may be worth your while to buy a special clay press from a ceramics or clay modelling shop. This is a tool specially designed for making shapes from clay. However it works equally well with margarine because it has much the same texture as clay.

A clay press consists of a metal tube with a screw at one end onto which changeable disks are fitted. The disks come in different shapes: circles, triangles, squares, etc.

Margarine is pressed through the disks from the tube by a plunger, giving a continuous ribbon of margarine in the shape of the disk you have fitted (fig. 7). The shaped ribbon of margarine is cut into whatever length is required. One popular brand of clay press is called the Kemper Klaygun.

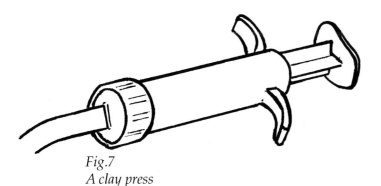
Comical chef

Reinforcing

You will find it necessary to reinforce the sheets of margarine in some of the shapes you want to make; some ribbons and bows for instance, as well as more elaborate work in thin strips such as flowing capes, the brims of hats, or the sails of a ship. To do this flatten out the shape you want on wet kitchen paper in the usual way, but spread the margarine thinner than necessary. Then cut out a piece of greaseproof paper, slightly

Fig.7
A clay press

smaller than the shape required, and place it on the margarine. Cover it with another layer of margarine and cut it to the shape you want. This will give you quite a strong, flexible, sandwiched sheet which can be draped, moulded into shape and attached to your model. If you want an even stronger sheet, substitute fine wire for the grease-proof paper, or better still use greaseproof paper and fine wire together.

Summary

1 Knives and other ordinary kitchen tools are perfectly adequate for most margarine models.
2 Specialist clay modelling or carving tools can be purchased to help create special effects.
3 Experiment with different tools to find those that suit your particular techniques and requirements.

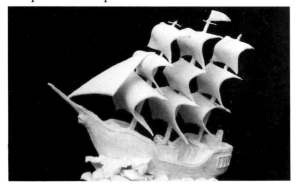

Sails reinforced with paper and wire

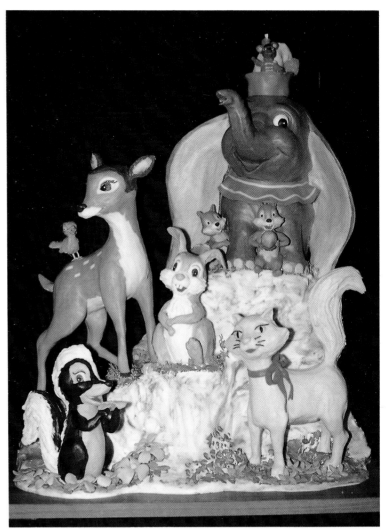

A variety of effects
© Disney

Special effects

Practice and experimentation will enable you to achieve all sorts of special effects on your margarine models; this section should help you with some of the more obvious and useful ones.

Hair

The impression of flowing hair is best achieved by pinching and pulling the margarine with the fingernails of the forefinger and thumb to form waves and curls. Add extra emphasis with a pointed tool. If your fingernails are not long enough to create an interesting effect use a serrated tool or a knife.

Make curly hair by using a pointed tool like a satay stick, cutting the margarine with it in a circular motion (fig.1).

Hair can also be made using a garlic crusher as described in Section 6. The clusters of threads from the crusher can be used on their own or intermingled with hair modelled in other ways where extra length is required.

Fur

The effect of fur is achieved in much the same way as that of curly hair. Different effects and textures can be created by varying the depth or angle of the cuts, the direction

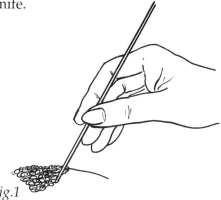

Fig.1
Using a satay stick to get the effect of wool

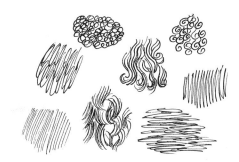

Fig.2
Different textured surfaces

and shape of the rings and circles or the lines you cut, and the tools you use to make them (fig. 2).

Clusters of strands from the garlic crusher can also be used very effectively to create the effect of longer shaggy fur. Experiment to find the best technique or combination of techniques to create the particular effects you want.

Marbelling

In contrast to these rough surfaces, a very smooth effect can be obtained by dipping the fingers in warm water and rubbing the margarine in small circles. Use the water to smooth the surface of the margarine and to remove bumps and ridges. The more you rub the smoother and shinier the margarine will become. It will emulsify and take on the appearance of marble. You can also give the margarine an extra shine by rubbing it down with cooking oil.

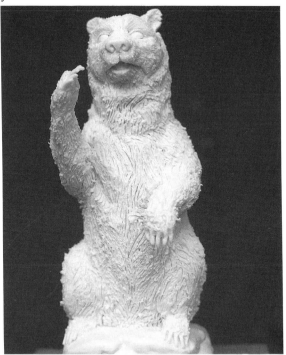

The effect of fur

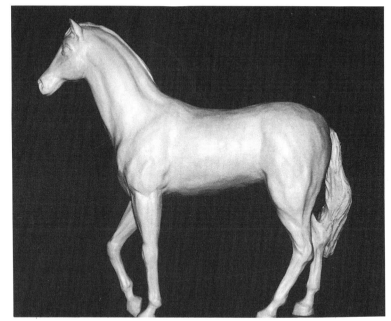

A shiny surface achieved by rubbing down

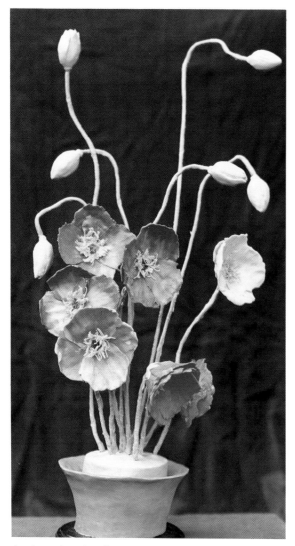

An imaginative flower arrangement

Flowers

Flowers can be made in a number of ways in either coloured or natural margarine. It is worth studying artificial flowers to note how the character of different kinds of flowers has been caught in simple ways. Experiment with different techniques.

Chrysanthemums can be made with bunches of strands from the garlic crusher (fig. 3 a). A few strands make the centre stamens for many kinds of flowers (fig. 3 b). Bunches of very short strands make the centre heart of a daisy (fig. 3 c). The ragged petals of a carnation can be made with quick scrapes from a block of margarine (fig. 3 d).

Petals of more regular shape may be formed and moulded with wet hands. If they need to be particularly fine and delicate it can help to work with the hands and margarine immersed in cold water.

Many kinds of petals and leaves are best made using the wet paper towel method, squashing and cutting them into shape and marking them with veins and texture for a more realistic effect (fig. 3 e).

Roses are attractive and simple to make. Start with a small petal and twist it into a cone shape to form the centre. Add petals round the centre, making them bigger as you move out from the centre, and give a curve and shape to the top of the petals.

Fig.3
Flowers and leaves

(a) *Chrysanthemum made with a garlic crusher*

(c) *Daisy. The petals are cut out on wet paper and the short strands in the centre are made with a garlic crusher*

(b) *Lily. The petals are made using the wet paper method, and the stamens a garlic crusher*

(d) *Carnation modelled using scrapes from a block of margarine*

(e) *Hand-moulded leaf. The veins are marked with a tooth pick*

Butter roses

Butter roses for the table or the cheese platter should be made as simply and handled as little as possible. Use very cold butter and cut it into a petal shaped wedge, or if you are making a lot of roses, several wedges of different sizes.

If one wedge is enough make it bigger at one end. Start with the largest wedge and take thin petal slices from it. The cheese slicer is a good tool for this. Take advantage of the curve that comes naturally with the cut.

Place three petals around the outside of the butter dish, and then another three between the first, and then another three between them, working inwards using smaller petals until the dish is nearly covered (fig. 4 a). Use about four layers of petals. Shape the central cone of the rose by twisting a petal with the help of cold water, add two petals to the outside of it (fig. 4 b) and place it upright in the centre of the dish. Butter roses like this look very effective, and, after some practice, can be made easily and quickly.

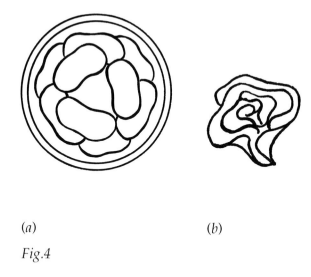

(a) (b)

Fig.4

Summary

1 Learn how to create special effects by experimenting with different tools and techniques.
2 Study real textures and effects carefully. If you understand why the real things appear as they do you will be able to develop better techniques for simulating their appearance.

Faces

Faces and facial expressions are the most difficult part of any margarine model and a great deal of practice and patience is needed to master them.

As margarine is a soft material the slightest inaccuracy or jog at the wrong moment will cause a ridge or a dent where it is not wanted and spoil the whole effect of the face.

This makes the preparation of a face a very laborious and exacting process.

The easiest faces to make are wrinkled and hairy ones like Father Christmas's. It is comparatively easy to give the right impression of his face, with its chubby cheeks and snub nose protruding above a bushy beard. A jolly expression is achieved by the suggestion of a smile and deep-set wrinkled eyes.

Heads

Start heads by forming an oval, or egg-shaped ball of margarine, remembering that a normal adult head is about one-sixth of a person's height. The younger a child is, the greater the proportion of its head to its height; in a small child the head is about a third of the child's height. Make sure you are as accurate as possible by careful observation as wrong proportions will spoil the whole model.

From your drawing determine the inclination and direction of the head, making sure that the neck and shoulders are positioned at the correct angle to the body. Do not start work on the facial contours until you are sure that the shoulders, neck and head are all correctly positioned.

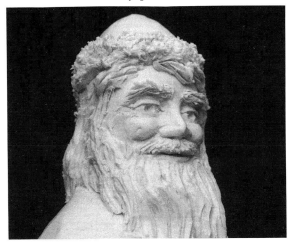

Father Christmas

Placing the features

Once you are satisfied that you have the proportions right and that the head is placed correctly on the neck and shoulders, divide the head in half both vertically and horizontally (fig. 1). This gives the starting point for the eyes. Hollow out the eye sockets along the horizontal half-way line and build up the nose on the vertical line.

Divide the face again twice horizontally, so that it is divided into four from the top of the head to the chin (fig. 2). The top line is the approximate hair line, and the bottom one marks the end of the nose. The lower lip falls about half way between the end of the nose and the point of the chin.

Next, start work on a profile (fig. 3). Shape the nose and mouth, and build up the chin, jawline and cheekbones with the help of your modelling tools. Turn to the other profile and repeat the process.

Looking from the front, mark out the size of the mouth and the width of the nose, and then shape the jaw, cheeks and forehead.

Make two small equal round balls and put them into the eye sockets, squashing them into place to form the eyeballs (fig. 4).

Check that the two sides of the face match each other by looking at the head from above, adding and removing where necessary (fig. 5). Check it also from below, perhaps using a mirror to help you.

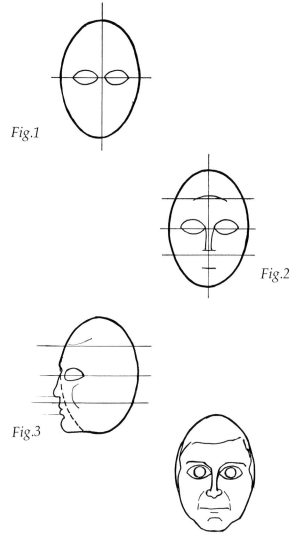

Fig.1

Fig.2

Fig.3

Fig.4

Fig.5

Work on a face from all sides, being careful not to lose its basic shape. A common mistake is to make the face too flat. This can be avoided by working from the profile as well as from the front, and always keeping the profile in mind.

From the profile view divide the head in half to establish the position of the ear. Ears are level with and about the same length as the nose. Divide the face half of the profile head into half again to pinpoint the corner of the mouth and the position of the eye (fig. 6).

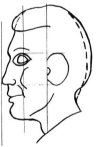

Fig.6

Character

A face is made up of a series of planes and angles which give each face its particular character. These are more angular in the face of a man with pronounced features. Women tend to have softer lines and smaller features, and children have rounder faces with fuller cheeks and bigger eyes.

Make the angles and features over-sharp and pronounced at first to develop the character. As the face takes shape keep checking to see that both sides match and that the head and features are still in the right proportion to the rest of the figure. It is very easy to get so involved in work on individual details that the model becomes unbalanced and the overall effect is lost.

Fig.7

Hair

When you are satisfied that the features are correctly placed and shaped it is time to start work on the details, starting with the hair. Shape the hair to frame the face, giving it texture as you work. If possible cover or half cover the ears with hair.

Ears and forehead

If the ears cannot be covered and must be modelled, a relatively simple way of doing them is to shape some margarine into a curled tube. Press this onto the head to form the outer edges of the ear, squeezing and smoothing the ends into the head. Hollow

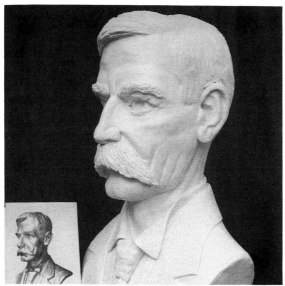

Bust of Henry Lawson

out the ear to form its main features and mould the lobe and ridges. Use a mirror to note the features of your own ear while you work. Check the ears from the front to make sure that they are level and the same size.

When the hair and ears are right, start work on the forehead. Smooth it and then add a frown or character lines if they are appropriate. Then form and shape the eyebrows.

Eyes

The effect of closed eyes can easily be achieved by cutting a line with a pointed tool at the bottom of the eyeball to form a ridge and smoothing the upper part of the eye into an eyelid.

There are several different ways to handle open eyes.

The easiest way is to leave the eyeball completely smooth or to mark it with a curved line to indicate the iris and the direction of the gaze. Other techniques for giving the impression of the irises range from making slight indentations for them to cutting deep holes. Experiment before deciding which method would be best for your model.

Add lids to the top and bottom of the eyes using thin strands of margarine and smoothing them into the face. Take care that both eyes are the same shape and are looking in the same direction.

Nose, mouth and chin

Mould the nose into the cheeks, adding and shaping the nostrils and forming the upper lip. Lips are formed by placing strips of margarine on the face and moulding them into the shape and expression you want.

The most difficult mouth to make is one with an open-mouthed smile, showing the teeth. If you attempt this, remember that the teeth are formed in a tighter curve than the mouth so that you have to cut deeply into the mouth round the teeth at the corners. You will need a sharp pointed tool to model the teeth. Now you can make the finishing touches to the chin, the jaw, and the cheeks.

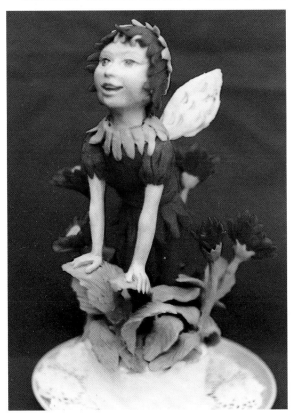

Pixie

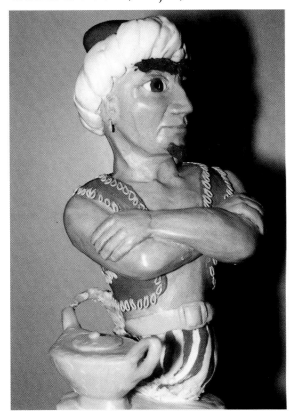

Pronounced features

Smoothing and finishing

If you are making a pretty young face it will need a particularly smooth surface. This can be achieved by rubbing the margarine with a finger or with a cotton bud dipped in warm water. Rub all over the face and neck with the warm water until the margarine has emulsified and you have achieved the degree of subtlety and smoothness the particular model requires.

Now study the overall effect and add any extra emphasis of character or expression, using a pointed tool. When you are satisfied smooth the whole face over to finish off (fig. 7).

The same principles apply when modelling animals' faces

Summary

1 Before starting work on a face make sure that the head is in the correct proportion to the body and set at the right angle.
2 Divide the head into halves horizontally and vertically to establish the eye and nose lines.
3 Divide the halves again to place the hair line and the upper lip.
4 Work from all angles, checking particularly from the profile to see that the face is not too flat and from above to make sure that the two sides balance each other equally.
5 Exaggerate the angles and features in the early stages of developing the character of the face, softening them later.
6 Only when you are satisfied with the main features add the details and smooth over.

Pretty young face

Colouring

The debate

Chefs of the old school prefer to use modelling margarine in its natural state and colour, arguing that that is the pure form of the art and relies only upon good modelling and design for its effect, but there is a growing group of younger chefs who approve of the use of colour in margarine models, or at least in some of them.

This contentious issue often leads to argument among chefs involved in competitive work, especially at salons culinaires, but traditional attitudes are gradually changing and more and more coloured models are to be seen on buffets and in competitions around the world.

Butter models

Whether or not it is right to colour margarine models, all chefs agree that butter carvings should always be presented with the butter in its natural state and colour.

Butter is recognised as a natural product intended for consumption, and butter carvings, which are carved with a knife and not moulded by hand, are more hygienic than margarine models which, whether coloured or not, are never meant to be eaten.

Choosing colours

Colouring models can add an extra dimension to their design and presentation. The colours can be co-ordinated to fit the decor of the establishment, or they can be an essential part of the theme of the model.

Provided colours are used sensibly and tastefully they can add realism and life to a sculpture. Colouring can range from a plain model highlighted with one colour—a white cockatoo with a sulphur crest for instance, or a lady's white dress with a single coloured bow—to a model in full colour.

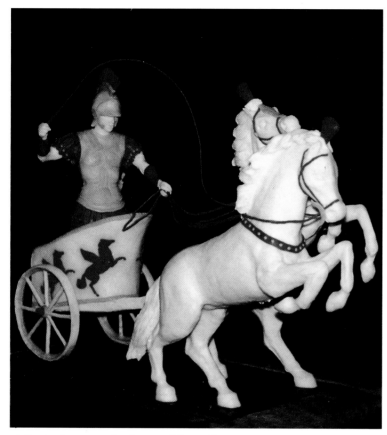

A limited range of colours adds realism

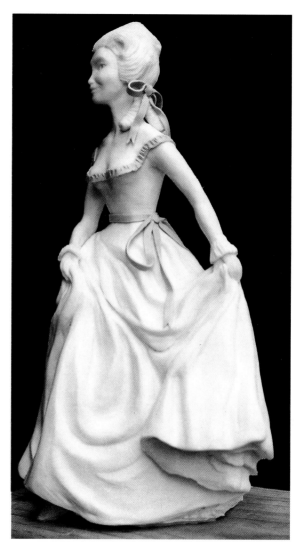

A single colour used as a highlight

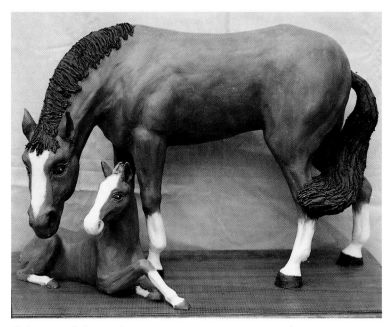

Colours subtly used

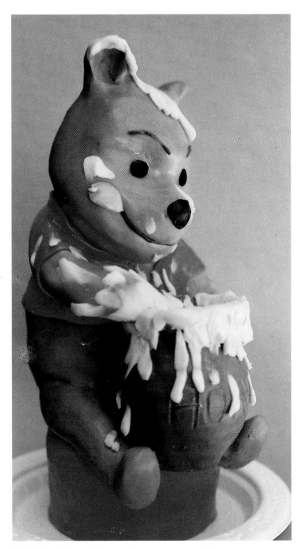

Bold, bright colours for a cartoon figure
© Disney

An infinite variety of coloured effects is possible—animal fur in various shades, gaily-coloured birds, figures with natural skin tones and accurately coloured hair and clothes, and so on.

The more colours used, the more complicated and time consuming preparation becomes. We therefore recommend that beginners practise and become proficient with plain margarine before attempting colour. You can gradually add colour to your models as you become more skilled and your techniques develop.

When the time comes to graduate to full-colour models make sure that the colours harmonize with each other and with their surroundings. Crude colours will detract from a design but subtle and well-chosen colours can be very attractive and make a presentation life-like and exciting.

Mixing colours

When mixing colours great care must be taken to work cleanly.

Each batch of coloured margarine must be kept separate and your hands and tools must be kept scrupulously clean so that the colours do not mix by mistake. If the colours mix it is easy to end up with a muddy and unattractive effect.

Even though coloured margarine models are not meant to be eaten, the margarine must only be coloured with non-toxic pigments, or oil-soluble colours. There are many varieties of colouring powders on the market, including the finger paint used in kindergartens. We recommend Williams Food Colours. The Williams Food Colour Lakes range is made of an edible powder and has a very good selection of colours.

Colouring powder is very powerful and you need use only a little of it to get the shades you want. Because it is oil soluble the powder will mix extremely well into the margarine provided that the margarine has first been moulded and softened up. You mix the powder directly into the softened margarine and knead it and manipulate it with your fingers until you get a completely even colour.

A basic knowledge of the effect of colour combinations is very useful as it will help you mix colours to produce the particular shades you want, for example the various greens which result from different combinations of yellow and blue.

Before colouring a large batch of margarine experiment with small amounts until you are certain how to achieve the shade you want. Note the colours you have used and how much you need in relation to the amount of margarine you are colouring.

When you are ready to colour the margarine for your model, be sure that you

mix enough. It is almost impossible to mix another batch in precisely the same shade because the colours change in a chemical reaction with the air. So calculate carefully how much margarine you will need and then add some for good measure. Any coloured margarine left over should be kept for future repairs.

Applying colour

If you want an evenly coloured smooth surface area, try to finish each colour application in one sitting. Because of the way the colours change in reaction to air, a surface applied one day will change so that colours added later, even if they are from the original batch of mixed margarine, will be slightly different the next day and give a patchy appearance.

Coloured models are made in much the same way as plain ones. You can work entirely with coloured margarine, or make a rough shape with natural margarine and then add coloured margarine only on the surface. If you are working with solid colours, avoid putting light colours over dark ones as the dark colours will gradually seep through and dirty the lighter colours above them. This seeping effect can also happen when dark colours meet light ones on the surface, so you must be prepared to freshen up the model from time to time to make sure it remains nice and bright with sharp definition between the colours.

To achieve clean, bright coloured models you need plenty of patience and a steady hand, but the results can be extremely satisfying.

Summary

1 Coloured margarine is becoming increasingly popular for modelling but is still disapproved of by some traditional chefs.
2 Never colour butter.
3 Do not attempt to work with coloured margarine until you have mastered the basic techniques of modelling in plain margarine.
4 Use only non-toxic colouring agents: edible oil-soluble colours or their equivalents.
5 Mix enough of each colour for the whole model in a single batch, as it is never possible to recreate a shade exactly.
6 Work cleanly and keep each batch of coloured margarine carefully separate.

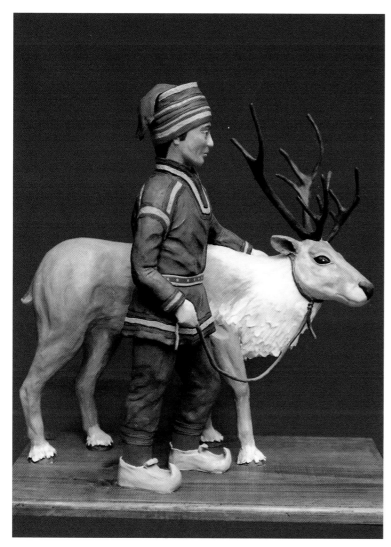

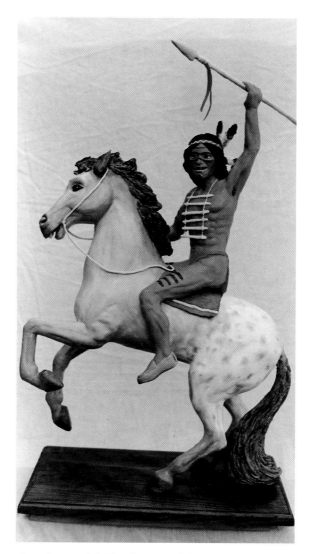

Complex, bright colours for a realistic model *An advanced full-colour model*

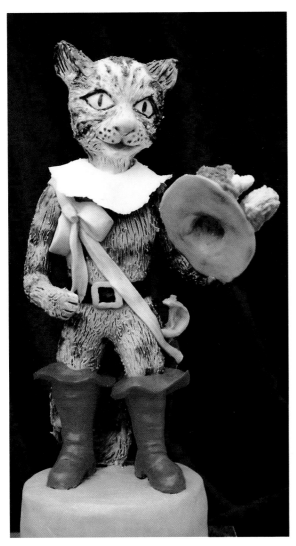

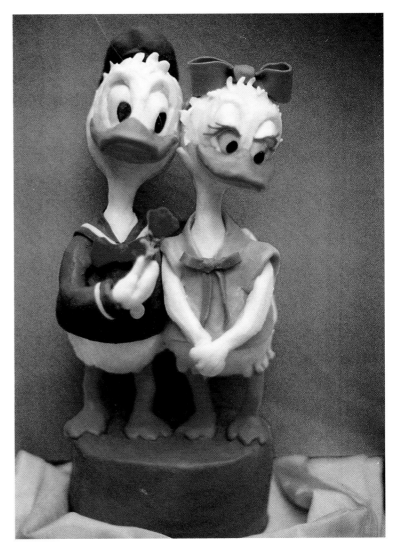

Different colours merge in Puss-in-Boots's fur

Simple, bright colours for Donald and Daisy
© *Disney*

Transportation

Moving models

Margarine models can be moved easily and safely from place to place if a few simple rules are adhered to. As most damage is done by dust and knocks, the most important rules are to make sure that the model is securely fixed and that it is properly covered.

If you expect that a model will have to be moved frequently, it needs to be particularly strongly made. A model which is constantly moved around an establishment, from the dining room to the kitchen and back, will need to be quite steady. If it is to be moved even more than that, for example if it is to be used by a caterer and carried from one place to another for different functions, then, of course, still more attention must be given to the weight and strength of the frame and the size of the base when the model is being made as it must be absolutely steady. It must be strong enough to survive the stresses and strains of being jolted over bumpy roads.

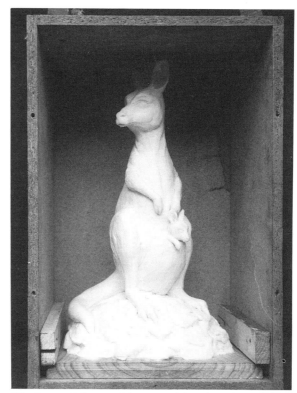

The base of the model secured by slats fixed to the side of the container

Boxing for transportation

The type and strength of the container used to hold the model while it is transported must, of course, depend on the likely difficulties of the journey. If rough handling is probable then the container must be adequate to cope with it. For a hazardous journey a sturdy box should be made of chipboard or plywood to fit the base of the model exactly and to allow sufficient room for it inside.

The opening to the container should be on one side of it. This allows the model to slide into the container with ease and control. Two slats of wood should be glued and screwed inside the box with just enough room to allow the base of the model to slide under them. They will hold the model steady while it is being transported because they will not allow its base to move, and, should the container be accidentally turned over, the model will come to no harm.

The finished model should be loosely and completely covered in thin plastic wrapping before it is slid carefully into the container. As an added precaution it is a good idea to screw the base of the model to the box from underneath with suitable counter-sunk screws. If the packing case may be handled by inexperienced or unknown hands it must be marked with 'Fragile' and 'This Way Up' labels.

Lastly, fix a handle securely to the top of the box. This not only suggests which way up the container should be held, but it also offers an easy way of handling it and therefore makes it less likely that the box will be roughly treated.

Summary

1 If a model is likely to be moved choose a suitable design.
2 Give the model a particularly strong frame.
3 Make a suitable box to fit the model.
4 Secure the base of the model firmly in the box.
5 Wrap the model in thin plastic to protect it from dust.
6 Seal and label the box, fixing a strong handle to its top.

Display and background

Once you have made your model, the next thing is to make sure that it is shown to its best advantage. Different kinds of displays suit different circumstances.

The reception room or foyer

If your model is to be on show in the reception room or foyer it must be put in a place where the guests can admire it easily when they arrive. The safest way to show a model off in a foyer is to put it in a glass case so that it is safe from poking fingers and from dust. Place the sculpture on a piece of good-quality silk and, if appropriate, add a card with a suitable legend, for example:

*To celebrate the Christmas Season
our chef has prepared this model of Santa Claus
from margarine.*

It is surprising how many guests will be astounded to find that the model is made of margarine, and it will be much admired and talked about.

You can improve the display of your showpiece by putting a mirror at the back of the cabinet so that the whole of the model, back and front, can be seen, and the presentation gains a sense of depth. Another possibility is to put the model on an electric turntable which slowly revolves, allowing

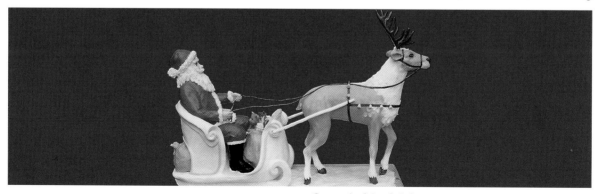

Santa in his sleigh

the guests to admire your work from all points of view.

Serving canapés

A small model complementing a platter of canapés at the start of a function can excite the eyes of the guests just as much as the canapés themselves excite their palates. The model will show what artistry there is in the kitchen and this will make everyone eager to enjoy the meal that is to follow.

The greatest danger to small models used to decorate trays of canapés comes from the staff. Guests are usually careful and admiring, but waiters can grow careless as they hurry round trying to cope with the demands of service. Empty salvers are often put down roughly, or platters are carelessly tilted, and the models fall over and are damaged.

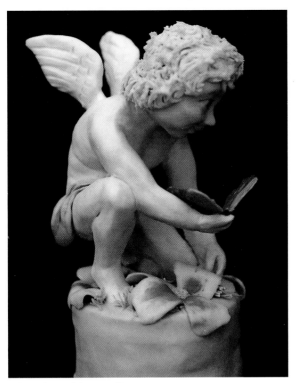

Cherub and butterfly

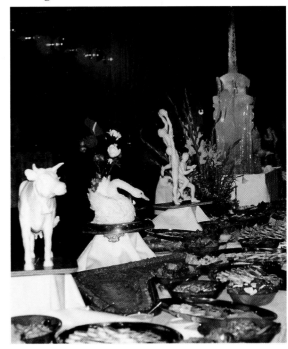

A buffet table

Staff training is therefore essential. Once the waiters realize how easily margarine models can be damaged they will take much more care with them.

A further safeguard is to put a small piece of margarine in the middle of the tray and press a doily over it so that a little of the margarine oozes through. Place the model on the doily over the margarine and gently press it into place so that it sticks to the doily and to the tray below it. This simple measure helps prevent the model from falling over when the tray is being whisked around by a busy waiter.

The dining table

A model displayed on a dining-room table is even more likely to be damaged than one on a tray of canapés, as guests will often poke it with their fingers in disbelief. Make sure therefore that any models which are likely to appear on dining tables are easy to repair.

The most serious damage happens when a model topples over, so it should be as steady as possible. Use a very heavy foundation or use a margarine-covered base. In the second case, the bottom of the base should be slightly melted and then placed on a plate which has a small amount of melted margarine in the middle of it. Allow this margarine to set and weld the model to the plate.

The buffet table

Models on a buffet table usually come in for more admiration than ones displayed in other places as the guests' attention is drawn to them as they look over the food to make their choice. And models on buffet tables can, of course, be larger and more impressive than models on canapé trays or on most individual dining tables.

While a good margarine model will greatly enhance a buffet table, it must be remembered that no matter how good the sculpture is, all will be lost if the food round it is not also well-presented. The skill shown in the presentation of the platters of food is just as important, if not more important, than a well-made model. A model will give height, and may provide colour, and show off the artistic skills of the kitchen staff, but it cannot replace good food preparation. Margarine models cannot make a buffet, they can only improve one.

The models used to enhance a buffet table should relate in some way to the food surrounding them. For example, a sculpture of a mermaid sunning herself on some rocks, or one of Neptune with his trident, has a clear sea theme and is therefore an ideal subject for a showpiece to be set in a display of shellfish. Let us assume that the food display consists of a large tray filled with crushed ice on which there are shelled and

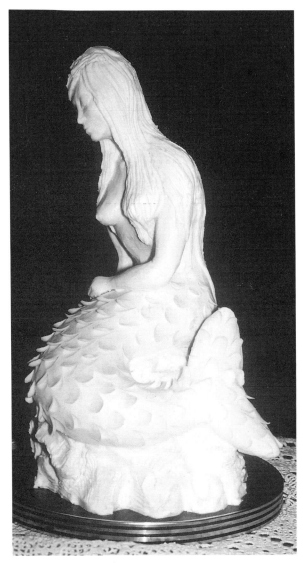

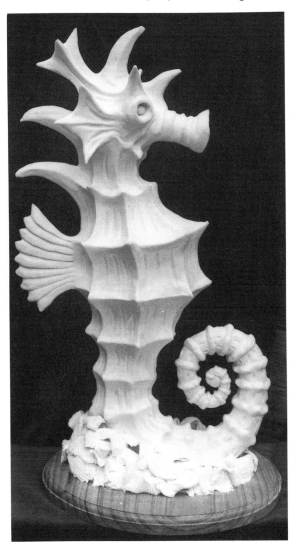

Another mermaid

Seahorse: a different model from the one on page 100

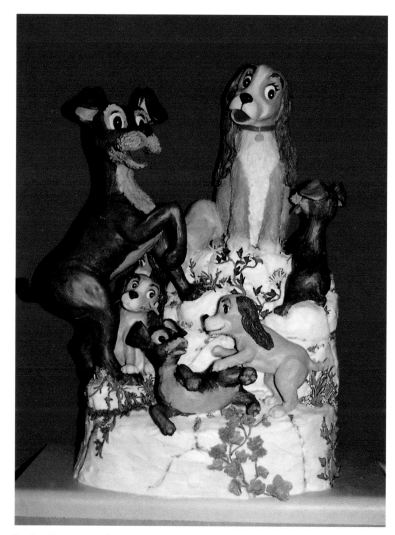

Lady, Tramp and puppies
© Disney

A raised display centrepiece

peeled prawns, opened oysters, and half lobsters attractively arranged and interspersed raviers of wedges of lemon and a seafood cocktail sauce. Your model might be placed behind this display so that it looks down at the seafood, inviting the guests to enjoy the feast.

Similarly, a model of a jumping fish or of a seahorse can very happily be used with the cold fish section of a buffet. Your guests will be even more delighted by the sight of a whole poached salmon delicately presented on a large salver if it has as a backdrop a well-made sculpture of a fish rising from the depths of the ocean.

Just as sea subjects complement seafood, so models of a bull, a cow, or a sheep naturally suit the cold meat sections of the buffet. A silver salver of thin-trimmed, medium-roasted sirloin of beef, arranged on a mirror of aspic, lightly coated with the jelly, and accompanied by appropriate garnishes, can be developed into a masterpiece by the placing of a small model of a bull's head in the centre of the platter.

Try placing a margarine sculpture of a magnificent rooster so that he proudly looks down on a platter of jointed roast chicken pieces (lightly coated in aspic to prevent the poultry from drying out) and see how the

Fanciful fish

Bull's head

guests admire him, and how their appetites are whetted.

The display centrepiece

Models appropriate to the occasion or the season—Santa Claus at Christmas, a tennis player when the championships are on, or a horse and jockey at the time of the racing carnival—are best used as centrepieces for

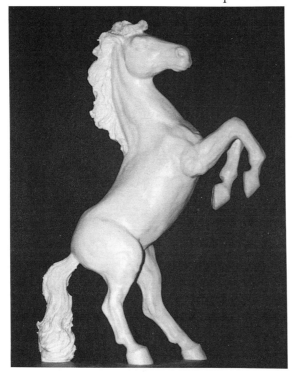

Rearing horse: a different model from the one on page 126

the whole buffet rather than to go with particular dishes of food.

The term 'display centrepiece' is almost self-explanatory: it is used to describe the major display in the very centre of the buffet table, and it has the object of capturing the imagination of the guests and attracting them to the buffet. The centrepiece on a buffet table is an hors d'oeuvre for the eyes, and it can contribute a great deal of pleasure to an occasion. It need not be made of margarine, of course, just as the other decora-

Cow

tions on a buffet table may be made from different things, but a really good margarine sculpture can be extraordinarily effective, to say nothing of the advantages of margarine over the other possible food-decoration media.

Place the centrepiece model on a very secure stand or on a cloth-covered buffet box, slightly raised so that it is higher than the rest of the table. Take a clean tablecloth or a piece of coloured silk and form it into a cushion shape.

Place the model in the middle of the cushion so that it sits there firmly.

A spotlight directed onto the centrepiece can add greatly to its effect.

Summary

1 Good display is important.
2 Models should reflect either the theme of the occasion or the character of the food being served.
3 Models are easily damaged. To prevent damage displays must be stable and staff must be trained to handle them.
4 Display aids like mirrors, turntables, and spotlights can be very effective.

The Melbourne Cup and horses

Storage

Shelf-life

How long a margarine model will last depends on how it is cared for when it is on display and the protection it is given when it is not on show. If reasonable care is taken and fresh margarine has been used to make it, a model should last about six months. A model should last as long as the margarine it is made of and margarine begins to go rancid in six months.

As earlier noted, one of the big advantages of margarine models is that they last a long time so that the cost of preparing them can be spread over several months. Unless care is taken to store them properly this advantage can easily be lost.

If possible keep margarine models in a cool, clean storeroom.

Although margarine models will in the end go rancid, do not attempt to keep them in a refrigerator. There are several reasons for this. The cold will, after a time, make the model brittle, and the moisture can encourage fungi on the model which not only destroy it but can introduce dangerous bacteria into the refrigerator. Also, margarine contracts and expands every time it is put into or taken out of a refrigerator. This leads to hairline fractures which can develop into considerable cracks when the model is moved.

Protecting the model

Dust is a major problem. Margarine seems to attract dust no matter where models are kept, and dirty specks of dust and dirt on the surface of a model quickly destroy its artistic effect and waste hours of hard work. The essential rule is: ALWAYS COVER YOUR MODEL WHEN IT IS NOT ON DISPLAY.

The material you use to cover your models must be light and porous. It must be light so that it does not mark or destroy any features of the model, and it must be porous so that there is good air circulation round it. This prevents a build-up of stale air which can make the margarine go rancid quickly. The ideal material is a light tulle. Tulle is very light and porous, and air can circulate easily through its fine holes, but it keeps dust and dirt off a model so that it is not spoilt.

While there may be many reasons why models need to be stored between functions and buffets, you should always be conscious that every time a model is moved or stored there is probably more damage done to it than would be done if it were left on

display. Don't move your models or store them away without good reason.

Repairs

Repairs inevitably have to be made to any model as, for one reason or another, they deteriorate. Finger marks and knocks can easily be repaired by smoothing them over. Dust is more difficult to remove. Each speck of dust has to be carefully lifted off with the point of a knife or a skewer, and the marks smoothed over. If dust damage is serious, you may have to scrape off the whole surface of the model and rework all the detail.

The unpacking of models needs close attention. The cloth should be removed carefully, making sure that it has not stuck anywhere. Inspect the model thoroughly, repair any marks and remove any specks of dust, and wipe down the base before the model is put on display.

Sooner or later the time will come when your model has to be thrown out. The signs are clear. At the slightest smell of rancid fat, or if the model is too dusty to be repaired, do not hesitate to throw it away and take on the challenge of making a new one.

Model covered with tulle to protect it from dust

Summary

1 Store your model in a cool place (but not in the refrigerator).
2 Cover your model to protect it from dust.
3 Do not move your model unnecessarily.
4 Keep your model in good repair.
5 No model lasts forever; when the time comes do not hesitate to throw it away.

Making a mermaid

This section will cover in detail the stages in the making of a particular model. We have chosen a mermaid because it requires the use of many of the techniques described in the earlier sections and will demonstrate how they can be applied.

To make any sculpture you must first think about and develop a feeling for the special qualities of your subject.

In this case the concept is a mermaid sunning herself on some rocks. She is pushing back her wet hair from her face with one hand and supporting herself with the other while she enjoys the sunshine. A slight twist of the body and head, and the one arm raised and the other on the rocks, add life to the model. The eyes are closed, in character with the pose.

What are the features of this sculpture? Among them are:

 The smooth body
 The jagged rocks
 The scaled tail
 The flowing hair
 The serene face

To achieve these effects all the skills of margarine modelling will be called into play.

Let us follow the making of the model stage by stage.

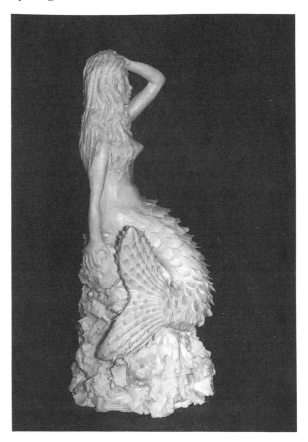

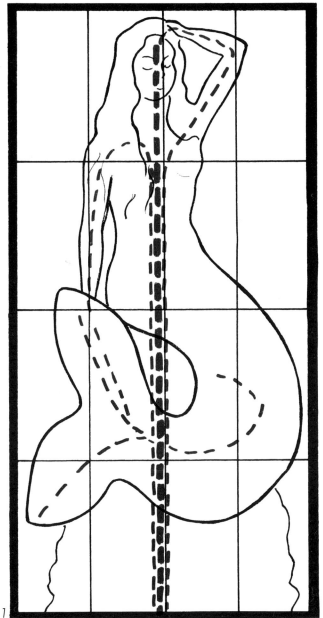

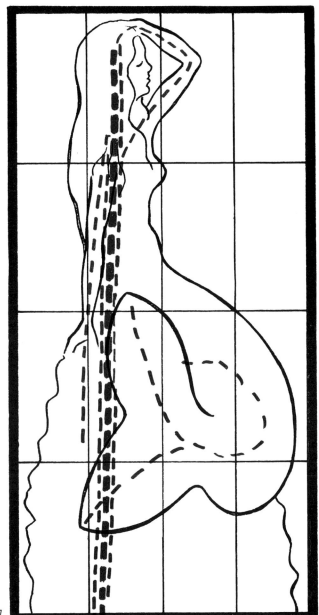

2:1

2:1

Fig.1
A drawing of the intended model is prepared to the required size (see Section 3). The drawing is then pinned up by the work table so that it can be referred to continually. A round wooden base is best for a model of a mermaid. The base will look better if you get the timber yard to turn the edge when you purchase the wood.

Fig.2
The main frame is attached to the base. A mermaid requires only a very simple straight rod as the main frame. The rod is threaded at one end with a stock-and-die set and then screwed onto the base (see Section 4). The nut is counter-sunk on the bottom of the base to allow the frame and base to stand steady.

Fig.3
The main rod of the frame should be off-centre (use the drawing to determine its exact placement) to allow the model itself to be in the centre. The base is sanded down, stained and given a clear protective coating of Estapol or a clear plastic coat.

Fig.4
The remaining framework is added. In the case of the mermaid quite a lot of styrofoam can be used to reduce the weight of the model and save margarine. The styrofoam is pushed onto the rod so that it is firmly fixed. Referring to the drawing, the remaining wire framework is attached using florist's tape as a binder. All the metal parts of the frame are then covered in florist's tape to prevent any rusting or the dark metal showng through the margarine in the finished model.

Fig.5
The rough-up stage now begins. The margarine is pushed onto the frame in small amounts.

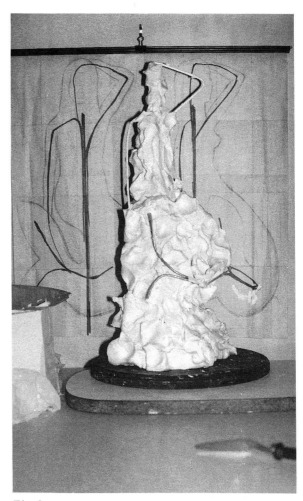

Fig.6
The first objective is to build up the basic shape from the front view to match up with the outline of the drawing.

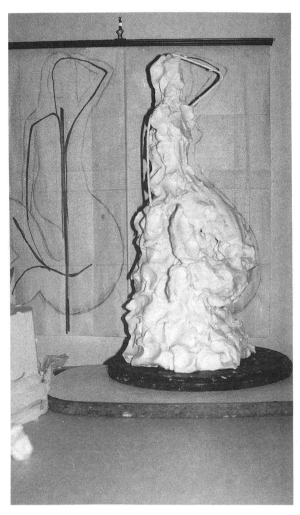

Fig.7
The model is then turned sideways and again built up to match the profile drawing.

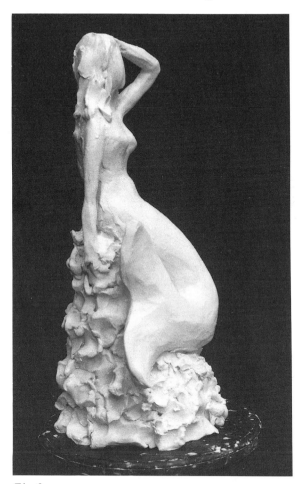

Fig.8
While constantly comparing the model with the drawing, build up the basic shape working from all angles until a satisfactory three-dimensional figure is achieved.

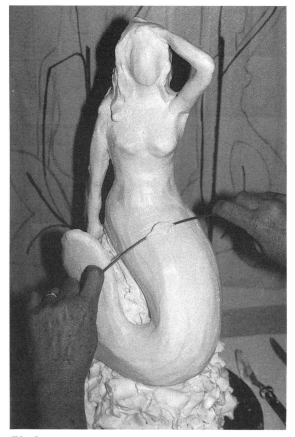

Fig.9
The margarine is packed down and smoo-
thed over, and pieces added or removed to
form the figure. Satay sticks are useful to
obtain smooth curves and angles. Rough in
the basic body features: the hair, face, arms,
and hands.

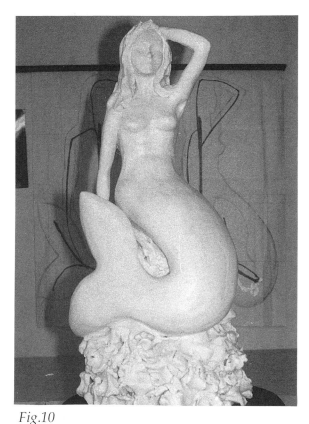

Fig.10
Before doing any work on the details, stand
back and look at the model, comparing it
with your drawing. Look at the model from
all angles, making sure that the basic shape
is exactly as intended. Stand about five feet
away from the model to get the best overall
view of its shape, and to see what correc-
tions need to be made to get it right.

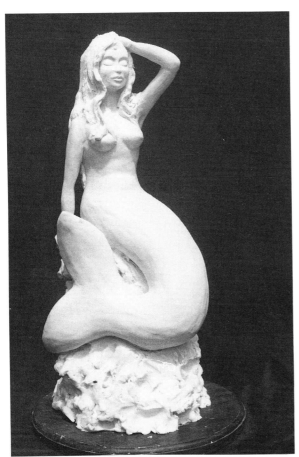

Fig.11
Once you are absolutely satisfied that the basic shape is right, start work on the details. Always start at the top and work down so as to reduce the chances of damaging parts that have already been finished.

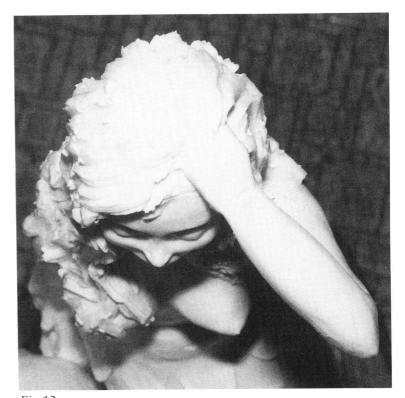

Fig.12
The face is the most difficult part of the model (see Section 8). Try to keep the mermaid's features small and soft, with just a hint of a smile. It is important to remember that the eyes are half way between the crown of the head and the chin.

View the face from above and below as well as from the front and the sides to make sure it is even and symmetrical.

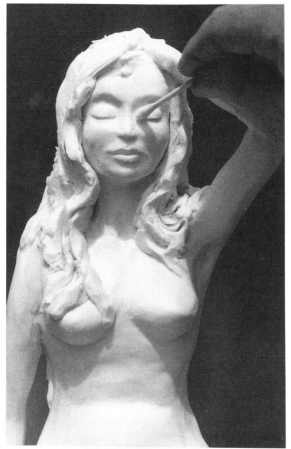

Fig.13
Make the face smooth by rubbing it with a cotton bud dipped in hot water. This will slightly emulsify the surface. Use a cotton bud also to work on the fine indentations of the face, such as the eyes, nostrils, and lips.

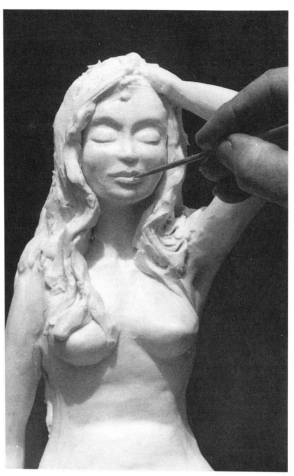

Fig.14
Extra emphasis is achieved by using a satay stick to mark the closed eyelids, the nostrils, the lips and the crevices where the hair overlaps the face.

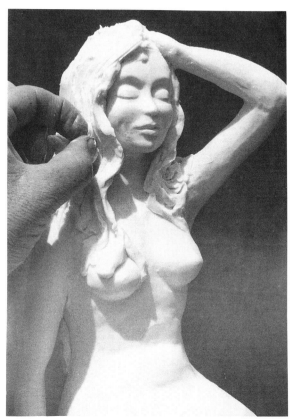

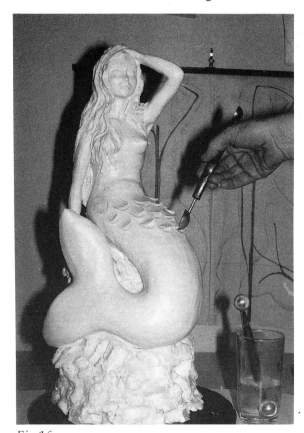

Fig.15

Shape the hair by pinching your thumb and forefinger together and pulling them through the margarine, creating undulating waves from the crown of the mermaid's head down to her breast. The fingers of her hand are buried in her hair with only the back of the hand and the wrist showing.

Fig.16

Add the last details to your mermaid's body, attending to her navel, breasts, nipples, arms, elbows, and her hand. When they are right rub down the model with warm water to emulsify the surface before using the parisienne cutter to make the scales on her tail (see Section 6).

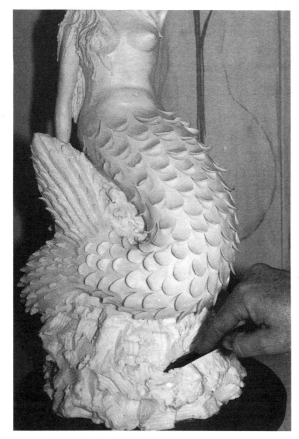

Fig.17
Finish the model by making rough rocks to contrast with the smoothness of the mermaid's skin, using a small knife with a serrated edge. If necessary, cut into the polystyrene base to make jagged rock-like shapes.

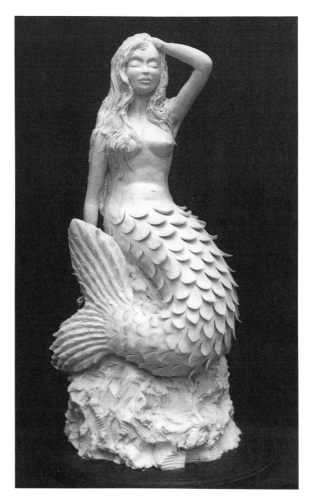

Fig.18
Clean down the base and your model is ready for display. (See Sections 10 and 12 for advice on transportation and storage.)

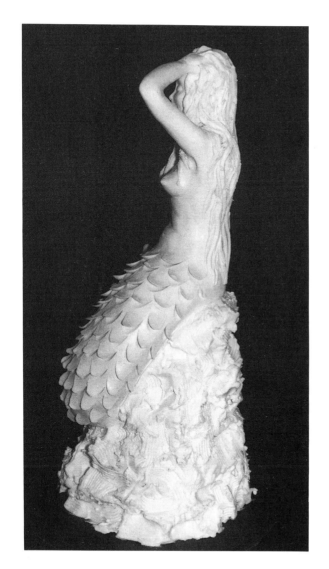

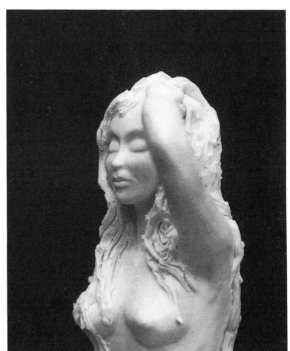

Model preparation

This section contains plans and advice on the making of a selection of popular models. They are arranged in groups by subjects and in rough order of difficulty. We strongly recommend that you read through the whole section covering all the models before you attempt to make any of them. Points are made in the description of some of the models which may well be helpful when making others.

Use the detailed description of the making of a mermaid in the previous section and follow the same process step-by-step when making the models dealt with here. In all the models refer to the basic instructions in the previous sections.

How to use the scale grid

The description of each model is accompanied by a design grid to help you make it. For obvious reasons these grids cannot be printed full-size in a book like this. A scale is therefore given for each model. Use the scale grids like this:

1 Decide what height your model will be.
2 Look at the scale shown on the bottom left corner of each grid. This indicates the width of the paper you will need relative to the height you have selected. The height is represented by the first figure and the width by the second.

If the scale indicated is 2:1 you will need a sheet of paper half as wide as the height of the model, 3:2 you will need a sheet two-thirds as wide as it is high, 4:3 you will need a sheet three-quarters as wide as it is high, and 1:1 you will need a square sheet as wide as the height of your model.

If the model is wider than it is high the same system applies, ie the first figure still represents the height and the second the width of paper relative to the height of the model, so that if, for example, the scale indicated is 3:4 you will need a sheet three-quarters as high as it is wide.

3 Cut the paper to the required size and fold the sheets so that the creases mark out the grid.

4 Draw in the grid with a coloured pencil to highlight the sixteen squares. Compare the shape of the squares in your drawing with those in the drawing in the book to ensure that your paper has been folded and marked correctly.

5 Carefully draw into each square an accurate enlargement of the outlines of the models. Take great care to copy each individual square exactly, noting the angles of the lines and the shape of the spaces in between them.

6 Do the same for both front and side views of the model so that both views are satisfactorily drawn in.

7 Next draw in the main framework of the model from both front and side views, using a different colour from the outline.

8 Pin up the two drawings so that they can be constantly referred to all the time you are working on the model.

9 Select the appropriate size of rod for the frame (see Section 4 on Bases and Frames).

10 Cut the rods to the required size by comparing them with the drawings you have prepared. Remember to ALLOW EXTRA LENGTH for bends and curves in the frame and for the extra length of rod which will be threaded and screwed into the base. How much extra length you allow to be screwed into the base will of course depend on the thickness of the base you have chosen.

11 Bend the lengths of rod using a strong vice to form the shapes of the frame. Each shape must be carefully compared with both the front and side views of the drawing to make sure that every rod is correctly shaped.

12 Cut the correct size of thread on each of the rods using a stock-and-die set and secure the rods to the base you have selected. Now you can begin to add the subsidiary framework (styrofoam, thinner wires, etc.) and start modelling with margarine.

The models described in this section are:

Fish
 Seahorse, Fish
Birds
 Swan, Cockatoo, Eagle, Rooster
Animals
 Sheep, Koala, Clydesdale horse, Fighting bull, Elephant, Lambs, Kangaroo, Rearing horse
Figures
 Snowman, Father Christmas, Girl with a basket, Neptune, Tennis player, Horse and rider, Swagman, Footballers

Seahorse

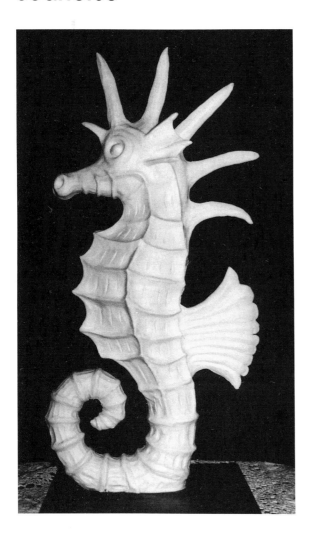

A model of a seahorse makes an ideal centrepiece for a display of seafood.

The most striking features of the seahorse are the outer fins extending from the top of the head down to the back. Emphasize them.

The model is relatively simple to make and it can be produced quite quickly.

The base should be particularly broad and firm because the model is inclined to be top-heavy.

The main support is a straight rod, preferably a mild steel rod which can be bolted to the base and bent over at the top to carry the muzzle of the seahorse.

The curving tail is supported by a piece of wire attached to the base of the rod and bent into an impressive loop. Thinner wires are attached to the main frame with tape to support the fins.

A model seahorse does not need a great deal of margarine so it is not necessary to bulk out the frame with styrofoam.

Once the base and frame have been prepared, shape up the rough model, closely following your drawing and any reference material you may have, possibly even a real dried seahorse.

Once the basic shape is correct work at the details until the effect you want has been achieved.

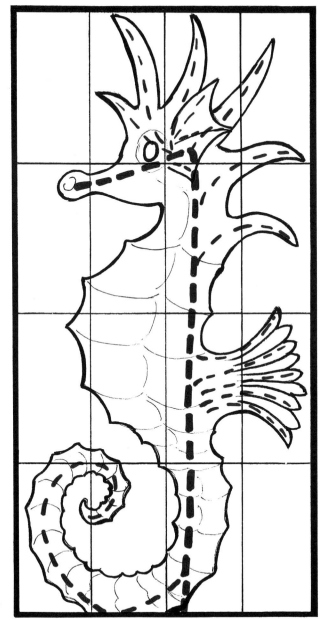

2:1

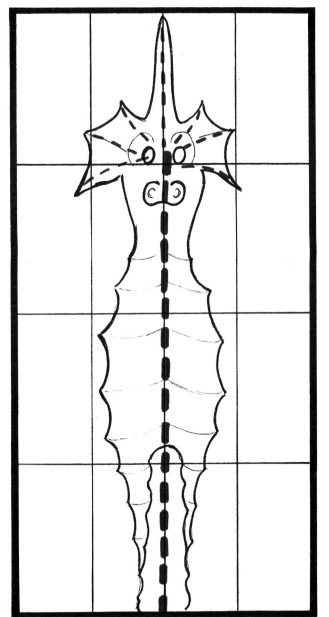

2:1

Fish

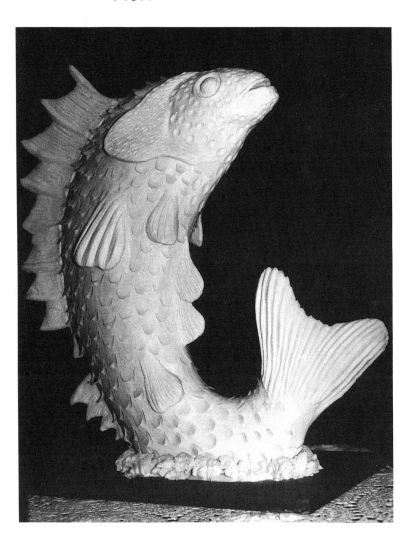

This is a very bulky model which makes an excellent centrepiece for a buffet table in the middle of a display of seafood.

The most striking features of the model are the angle at which the fish is caught rising from the depths of the ocean and its delicate fins which can be given special emphasis.

The heavy frame for the model is made from three metal rods, with supporting wires attached as shown in the drawing.

Because this is a bulky centrepiece use styrofoam to take up the bulk of the shape, pushing it down onto the main rods. You should be able to achieve the basic shape with styrofoam before adding any margarine. Spread the margarine over the frame and styrofoam to the rough-up stage. When the shape is right begin to add the details. Use a parisienne cutter to make the scales (see Section 6).

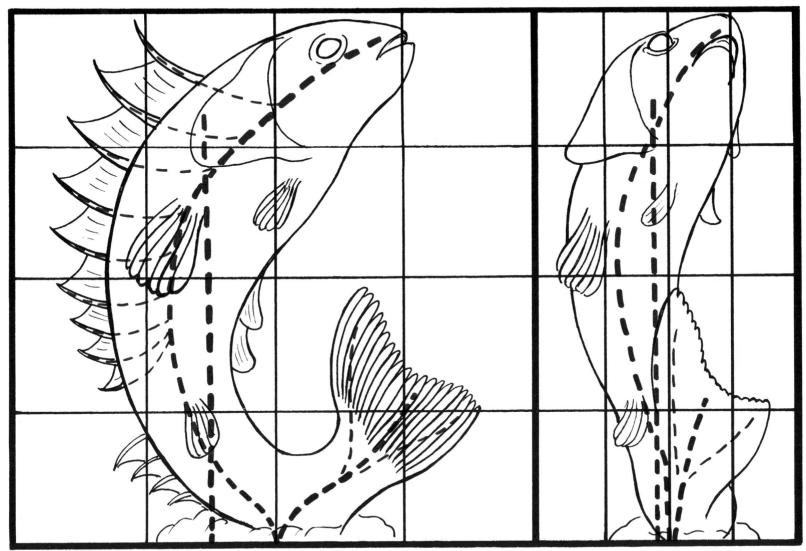

1:1

2:1

Swan

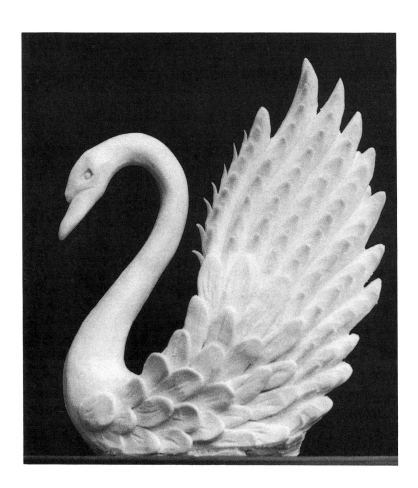

Model swans are very gracious. They generate feelings of love and sincerity and are suitable for almost all occasions.

There are no limitations to the use of model swans. They may be used time and time again at a variety of functions during the year.

Two white swans are particularly appropriate for decorating the table at a wedding buffet, and make an excellent central theme for wedding receptions.

The model is a very easy one to prepare and is suitable for a beginner because the effect does not rely on exact realism but on the general impression of the long curved neck and graceful wings with stylized feathers.

The frame consists of two main supports for the wings, each with interwoven wires to support their bulk, and a long rod bent in a sweeping curve from the base to carry the head and neck. This rod should extend as near as possible to the end of the beak.

Stylized feathers can be prepared quickly by using a parisienne cutter (see Section 6) or, more realistically, by making each feather separately and then moulding them onto the model.

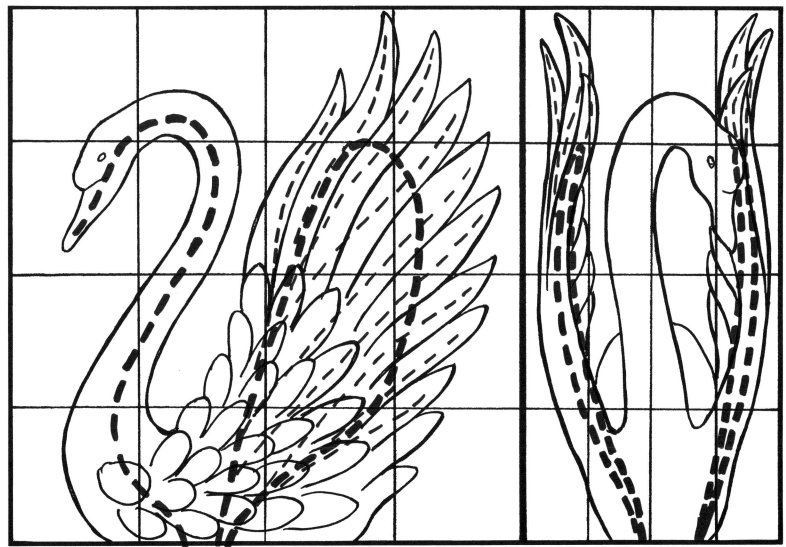

1:1

2:1

Cockatoo

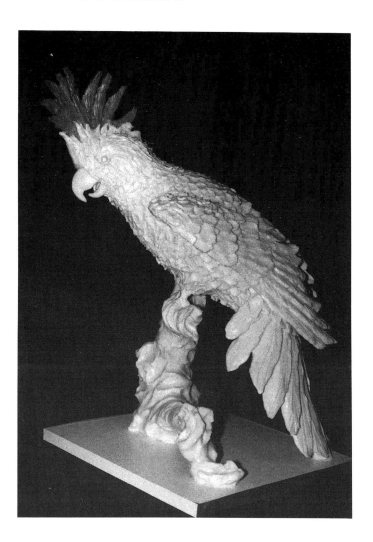

The features to emphasize to capture the character of this model are the fluffed-up crest, the puffed-out wings, and the fanned tail, combining to give the impression that the bird is screeching and excited.

The main frame of the model is a relatively simple construction, consisting of two heavy-duty supports one of which extends from the base through the log and to the centre of the wing. The other is fixed into the base at the end of the tail and extends through to the top of the head.

Two medium-sized wires are then added to support the wings, and then lighter framework is attached to hold the outer feathers.

This becomes quite a complicated framework and care should be taken to make sure it is right before you begin to add any margarine. When completed the framework should give an impression of the shape of the bird.

The wing and tail feathers must be individually made and laid to overlap each other. Start at the end of the tail and the trailing edge of the wing and work upwards with each layer slightly smaller than the one before. Mark the long tail feathers with a modelling tool to give the impression of fine feathering.

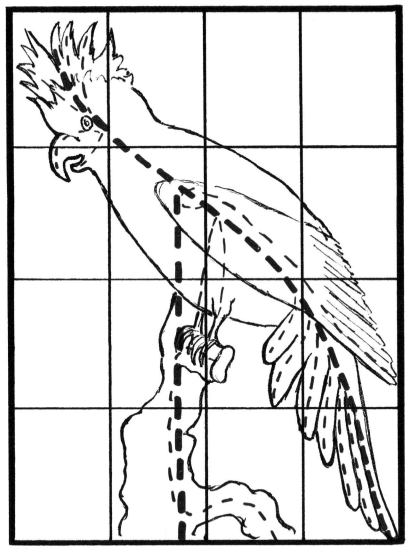

4:3

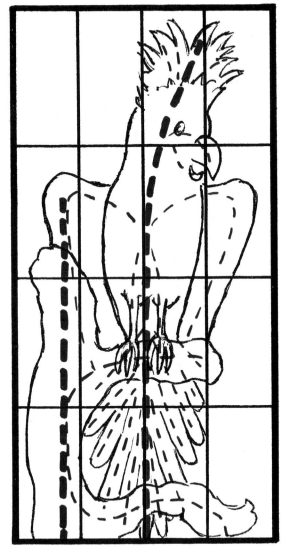

2:1

Eagle

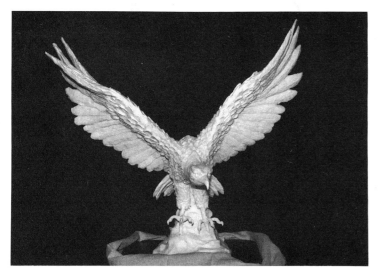

The eagle is probably the favourite subject of chefs around the world for table decoration. There is something irresistibly impressive in the power and character of this beautiful bird of prey, and it makes an ideal table highlight for a range of occasions.

The eagle is a popular subject for ice carvings, and often it is portrayed in chaudfroid or moulded in chocolate, but none of these forms of food decoration can realize the full potential of the subject as well as a margarine sculpture. Margarine best allows the chef to capture the fierce power of the bird because the features can be moulded and re-moulded until the feeling and full character of the subject have been obtained.

The features to concentrate on are the powerfully spread wings which dominate the model, and the dangerous outstretched talons, the curved flesh-tearing beak and the threatening deeply-set eyes with overhanging brows which give it a feeling of savagery.

The outspread wings take up the main part of the model both in the time needed for their preparation and in their weight. They make the model top-heavy and fragile, and therefore difficult to transport.

The design of the model with its talons outstretched allows the frame support to come from the rocks below the bird. The frame is very complex. It consists of two very sturdy supports from the main base, strong enough to support the wide heavy wings. A third main rod extends from the beak to the tail and back through the rocks to support the bird's body.

Each important wing feather has to be made individually and should have its own supporting wire attached to the main frame. The feathers are made in the same way as those of the cockatoo described in the previous section.

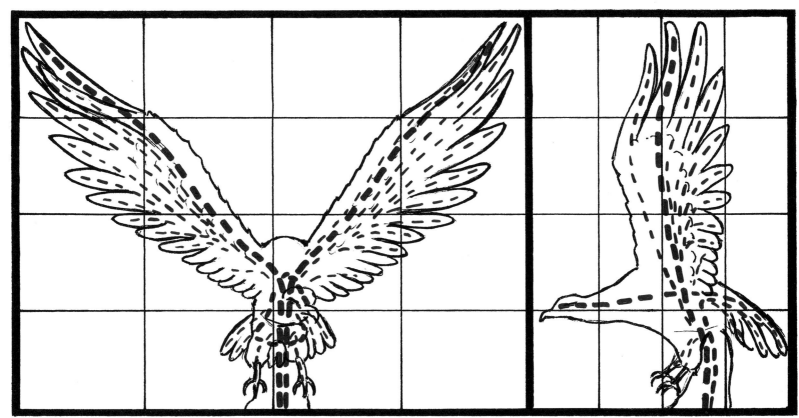

3:4 3:2

Rooster

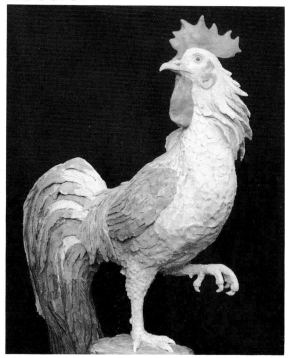

Here we have a proud and handsome bird overlooking his flock and ready to face any threat to his superiority. We have modelled him in coloured margarine to make the most of the beautiful colours of his plumage, but the subject can also be very effectively handled in plain margarine.

The main frame consists of three rods, one of which goes through the leg and up through the body to the top of the head. A piece of styrofoam is pushed down onto it to form the base of the tree trunk.

The other two rods are attached at the base of the tail.

Both then support the large tail. One of them goes through the body to hold the raised front leg, while the other acts as a second support for the body. A small round piece of styrofoam is put in the middle of the body to reduce the model's weight.

Our rooster has a bright red comb, and the rest of him is covered in feathers in a glorious range of colours.

It is best to do the rough-up stage using plain margarine, and only use coloured margarine when the feathers are added.

When you are satisfied with the rough-up, prepare batches of margarine in different shades—red, blue, yellow, green and brown—for the comb and coloured feathers.

Although we recommend that most models should have the details added from the top down, in the case of a bird the opposite applies. In order to overlap the feathers naturally, start at the tail and work up towards the head, subtly changing from one colour to the next.

You will need a good colour picture of a rooster or a good china ornament to help you capture the way the colours merge.

There is a colour picture of the Rooster on page 6.

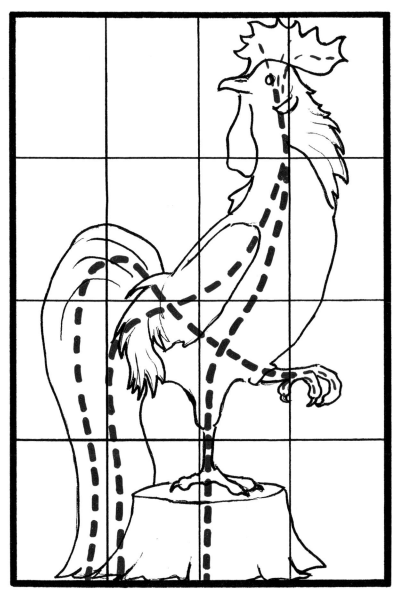

3:2

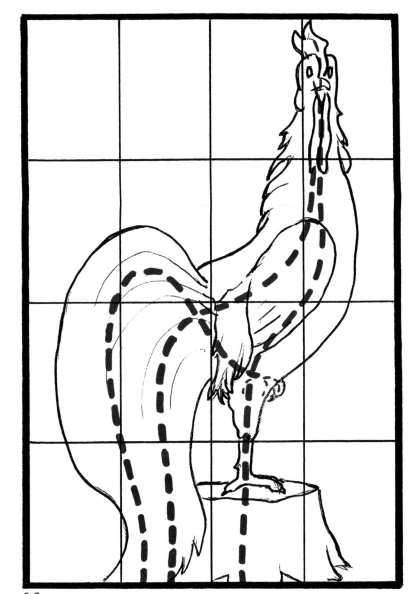

3:2

Sheep

This model is easy to make and travels well. It suits a variety of occasions. We recommend it for beginners even though it takes a good deal of patience to achieve the woolly outer layer.

The model consists of a very simple frame supporting a large thick-set body with only a suggestion of where the legs and body meet. The fleece conveniently hides the anatomical details. The only real difficulty is the face, and even that is a relatively simple one to make convincingly.

Use a lot of styrofoam, wired to the main frame, to take up the bulk of the body and to control the weight of the model. You can cut the styrofoam into the rough shape of the body after it has been fixed to the main frame.

Pack the margarine solidly onto the frame and mould and shape it in the usual way. There is no need to smooth it down before using the point of a satay stick to cut deeply into the margarine to give the impression of thick wool.

Emphasize the folds in the wool, particularly below the neck, which give some character to an otherwise plain shape, and don't forget the ears, just definable above the woolly head. The most striking features, though, are the curling horns. They are supported by bent wire buried deep in the margarine.

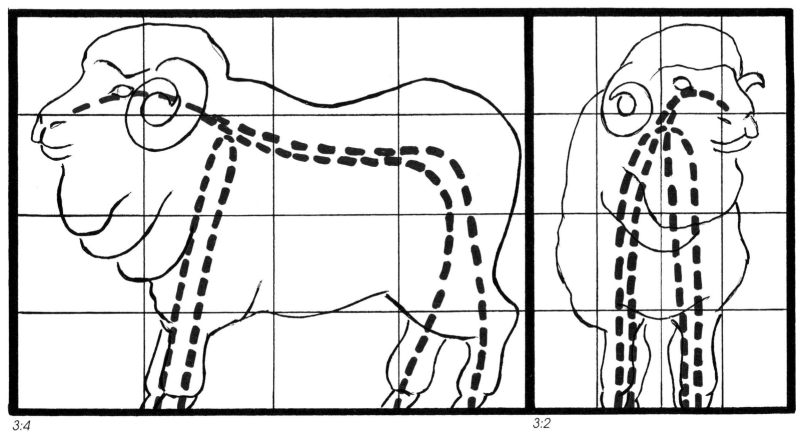

3:4

3:2

Koala

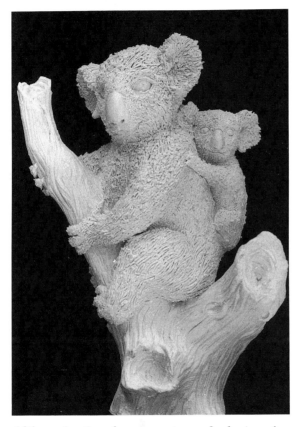

Although the framework and design for the koala is quite simple, it is not easy to capture the character of this wonderful cuddly animal in a margarine model. It is difficult to give the impression of her bushy body and large fluffy ears in a solid naturally smooth material like margarine.

You will need plenty of reference material — pictures and toy models, for example—to study when planning and making your model if you are to catch the koala's uniquely attractive qualities in margarine.

Important features which need to be noted include the receding chin, the big smooth nose, and the unusual paws, each with two thumbs or opposing fingers with large claws.

Our model has a frame consisting of three main rods bolted to a base, with another strong wire attached to support the baby koala on its mother's back.

Use plenty of styrofoam to take up the bulk of the body, but remember that in this case you must have a layer of margarine all over at least 2 cm thick so that your satay stick can cut deeply enough into it to give the effect of fur.

The baby koala's fur can be made to seem different from its mother's by cutting tighter and shallower circles with your satay stick. Hide its paws in the fur on its mother's back.

The tree trunk, with its flowing lines and knotty holes, gives a nice contrast of texture and shape.

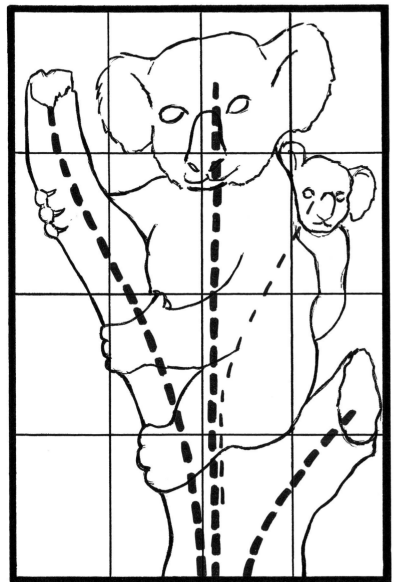

3:2

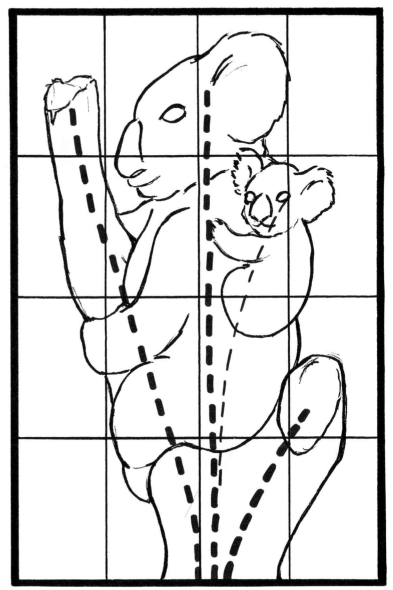

3:2

Clydesdale horse

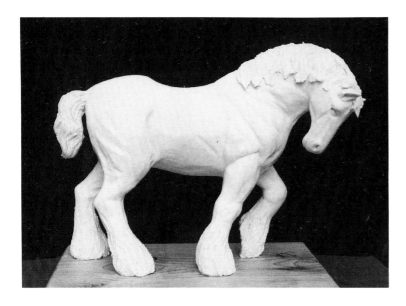

Almost everyone loves horses, and a sculpture of a magnificent Clydesdale makes an impressive display which is sure to win the chef compliments from delighted guests at functions of all kinds.

The Clydesdale design makes a stable strong model which travels well thanks to the four sturdy legs each with its own support.

The effect to be achieved is a combination of power and grace. The impression of strength can be given by exaggerating the muscles with deep lines, and giving the animal a powerful chest and hind legs. The feet should be thick-set and covered with hair, which can be modelled with a serrated tool or your finger nails. The texture of the mane, tail, and feet contrasts interestingly with the body which should be smooth and shiny.

Grace comes from the curving neck bearing a head held proudly, the slightly raised front leg, and the gentle sweep of the mane. The tail should be neat and short.

Your local library will have plenty of material about Clydesdales as they are very well documented animals and not difficult to research.

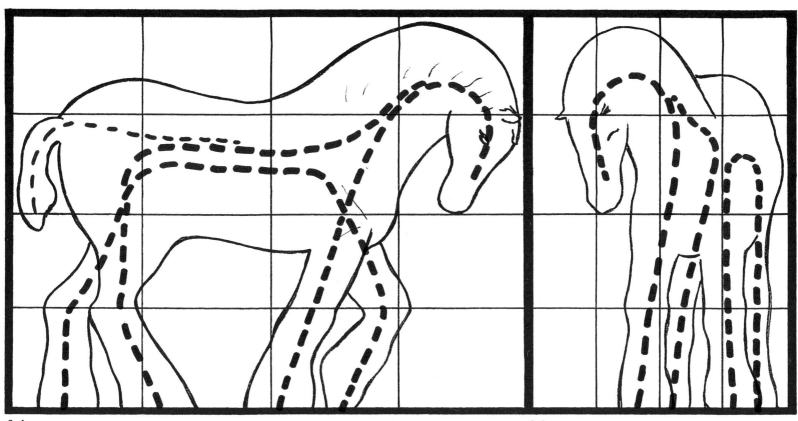

3:4

3:2

Fighting bull

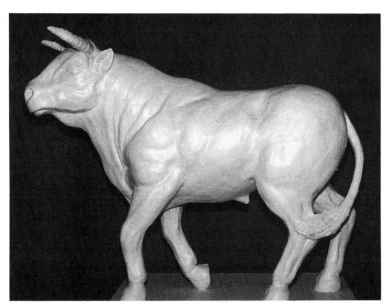

This fighting bull, pawing the ground and ready to charge, is very different from the farm animal pictured on page 30. Here the emphasis is on fierceness and power and so the taut muscles and aggressive stance of the animal must be emphasized.

A good model of a charging bull requires quite a lot of research as proper proportioning of the body and correctly placed muscles are essential if the full force of the subject is to be conveyed. Fortunately, small plastic models of fighting bulls are popular toys easily bought in toy shops, and they can be very useful references if supplemented, as usual, by pictures and photographs.

The fighting bull travels well because his stance and large body demand a sturdy and steady frame based on three well-placed rods screwed into the base to support each of the four legs. One of the rods is bent over and screwed to the base at both ends to support two of the legs. The bulky main body also allows a good deal of styrofoam to be used, which keeps down the weight and cost of the model.

After you have completed the rough-up stage and achieved the right shape, work at the model to emphasize the well defined muscles. Then smooth down the body to a shiny finish.

Points to be noted include the deceptively long body of a fighting bull, and its relatively long thick neck and pointed horns. Do not forget that bulls, unlike horses, have cloven hooves.

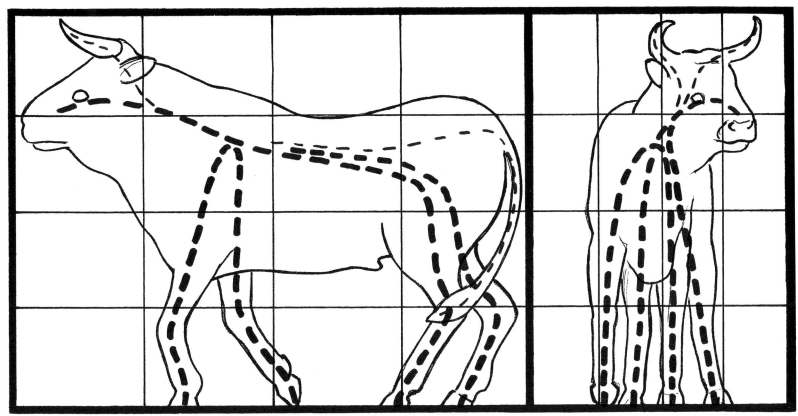

3:4

3:2

Lambs

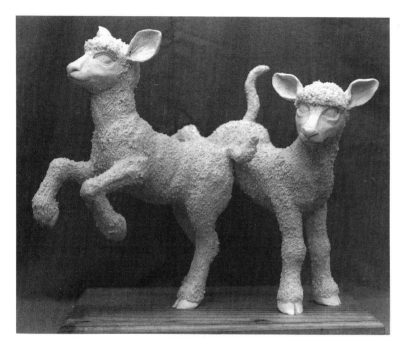

Gambolling lambs symbolize springtime and the re-birth of nature. Each lamb has only two feet on the ground which helps to give life and vitality to the model. It can be made quite stable by using an interconnecting framework so that there are four main supports, two through each lamb, the lambs supporting each other.

The framework is complex, and the model will fail unless it is skilfully constructed. You may find it easier to make a mockup first. Use a thin-gauge wire to bend into the shape of the model, then use this as a guide to help you to bend the thicker rods to the correct shape. It should be possible to visualize the lambs from the framework alone.

The plan shows one of the lamb's back legs in the air.

They appear foreshortened in both views because of the angle of vision. These legs are supported by two rods firmly attached to the main frame. To get them the right length bend the rods using the other lamb's back legs as a pattern. Attach thin wires for the tails and ears.

Note the large alert ears, the ridge of wool which covers the crown of the head and stops abruptly at the large wide eyes, and the knock-kneed legs which get thicker at the bottom and have cloven hooves.

You can achieve the impression of the woolly coats by using a thin satay stick to make tight curls all over the surface of the margarine. Lamb's wool is shallower and tighter than the wool on a full-grown sheep so the model should be given a much smoother finish before you work at the texture of the wool.

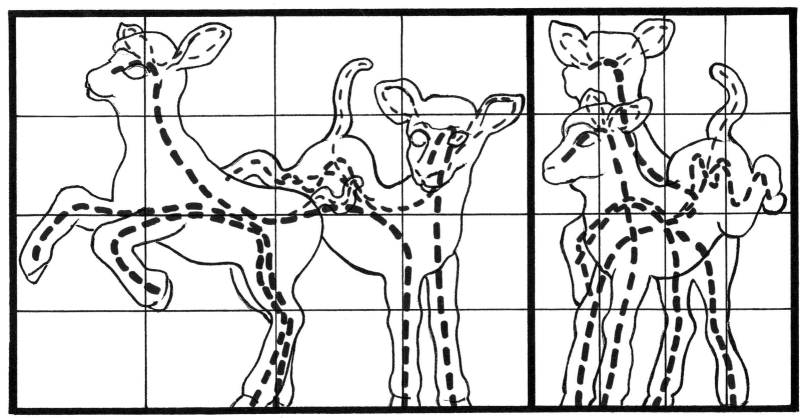

3:4

3:2

Elephant

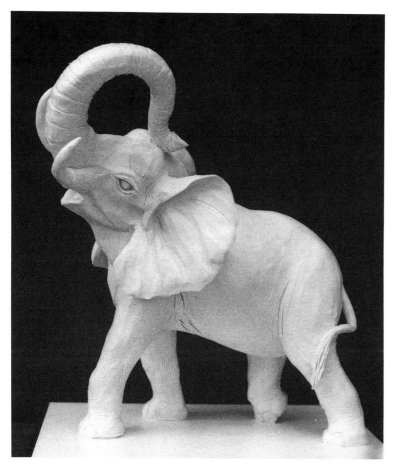

The elephant is a bulky, solid animal, and makes an ideal subject if you need a stable model that will be moved around a lot. His thick legs allow very strong supports, and yet his bulk makes it possible to use plenty of styrofoam so he need not be enormously heavy. He can be made even stronger by having one of the main supports extend from the front leg, through the curving trunk, back to one of the hind legs, as in our example.

Although he is big and bulky the elephant need not be stolid and boring. Our elephant is defiantly throwing back his head and raising his trunk in a sweeping backward curve.

African elephants are more impressive than Indian ones because of their larger ears and bigger tusks.

Fortunately for the modeller, an elephant's baggy skin makes it unnecessary to be exact in the placing of the muscles; all that is required is the right basic shape and the impression of a loose, wrinkled hide. To get the wrinkled effect scrape the margarine criss-cross with a serrated modelling tool.

The main thing is to get the basic shape right. Work at that until your model has the right proportions and character. You will then find that the details and finish are relatively easy. But, though a model elephant is conveniently stable and not too difficult to make, it will look most impressive in any display.

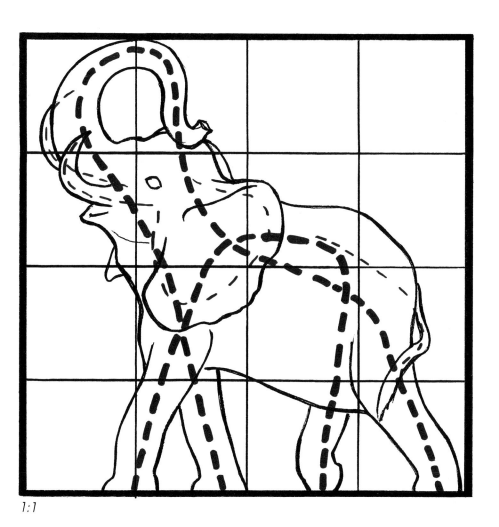

1:1

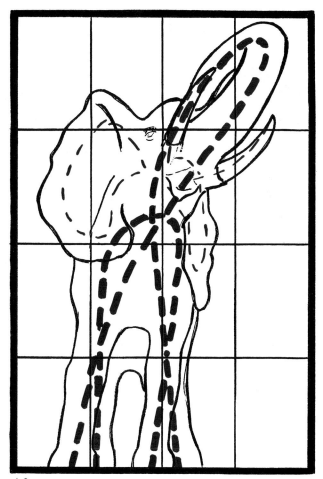

4:3

Kangaroo

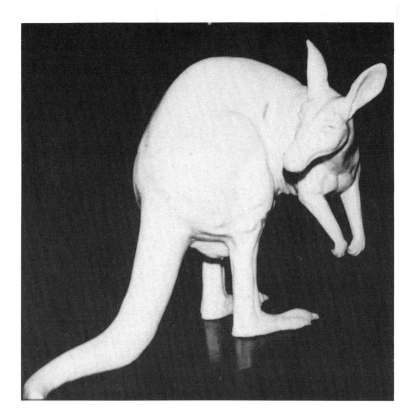

The kangaroo in a unique animal, recognized all over the world and immediately associated with Australia. It makes an ideal model for use as a centrepiece for a dinner or a buffet with an Australian theme.

We have selected a stance for our model which emphasizes the kangaroo's characteristic curiosity, as well as showing off its other unique features. It is caught bending low and turning inquisitively, with its ears high and open.

Particular care must be given to planning and to the frame of the kangaroo. Its low curved posture requires a complicated frame which must follow the flow and movement of the body. It is essential to get the curving shape of the animal's body right when the frame is made.

The main framework consists of three metal rods, two of which come up through the hind legs and are bent round to support the front paws. The third rod extends from the end of the tail in a sweeping curve up to the head.

Use a modest amount of styrofoam, fixed to the main frame, to take up the bulk of the body. Add thin wires to support the ears and the individual claws on each paw, and then you are ready to start the rough build-up of the margarine.

When researching the model find plenty of pictures of kangaroos doing all sorts of different things and standing in different postures, and study them so that you become thoroughly familiar with the unique features of this extraordinary animal. Posters are a good source.

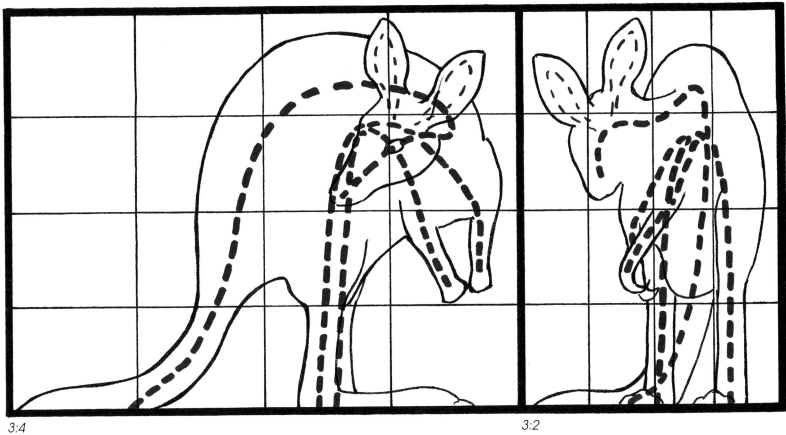

3:4

3:2

Rearing horse

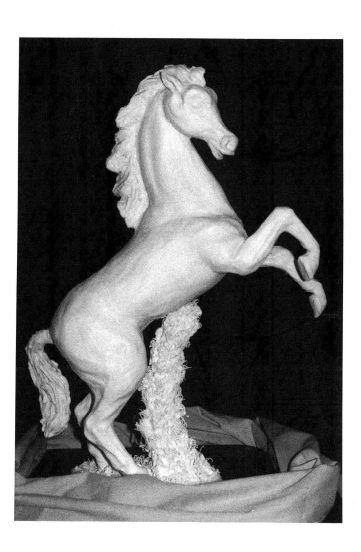

This exciting lively model will please the most demanding guest. It has the advantage of height, enabling it to lift any buffet table. We find that it is best made with plain margarine, contrasting with a heavy grained and highly-polished base.

Model horses require good research and reference materials as their shape is difficult to master. Newspapers are a good source as the racing pages are full of pictures of horses in all kinds of positions. Model horses are popular toys, and porcelain ornaments of them are easy to come by. And libraries, of course, have plenty of books with good pictures of them.

The rearing horse needs a particularly strong frame as it has to support a considerable weight. The main frame consists of three supporting rods; two go up inside the hind legs and extend through the body to the front legs, and the third one (which can be very heavy) forms the central support. It rises hidden by a bush from the base, and continues through the body to carry the head.

A twist of the head to one side adds to the spirited design. Pay special attention to the head. A horse's head, particularly the head of an excited horse, is not easy to capture, and may well need quite a lot of work before it is right. Give the mane and tail bold folds of hair.

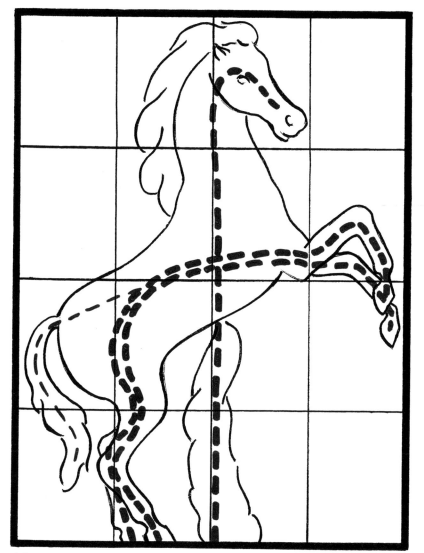

4:3

2:1

Snowman

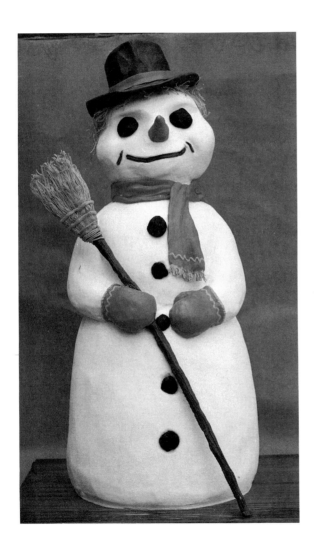

A model of a snowman will enhance most buffets, particularly if displayed near a suitably cold tray of ice or ice creams.

He is just right for occasions celebrating mid-winter or the opening of the skiing season, and of course, in the Northern Hemisphere, he is one of the symbols of Christmas time.

The model can be large or small; small for an individual table, large for a buffet.

The frame is simple, consisting of one metal rod with wires attached with florist's tape to support the arms, and with a secondary supporting rod or satay stick, depending on the size of your model, to carry the broom.

As a snowman makes a bulky model use plenty of styrofoam to keep down its weight and the cost.

The snowman is basically white, but your model will be more striking if you use a little coloured margarine for some of the details. In our example we have used only three colours: yellow for the hair, broom and scarf fringe; red for the scarf, mittens and hatband; brown for the hat, the big eyes, and the buttons which have been made to look like stones.

Model the mouth so that it looks like a stick and give the nose the shape of a stubby carrot. The hair and the brush are made of strands of margarine obtained from the garlic crusher (see Section 6).

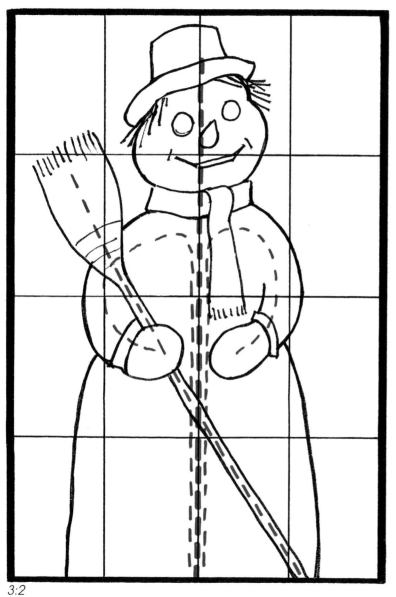

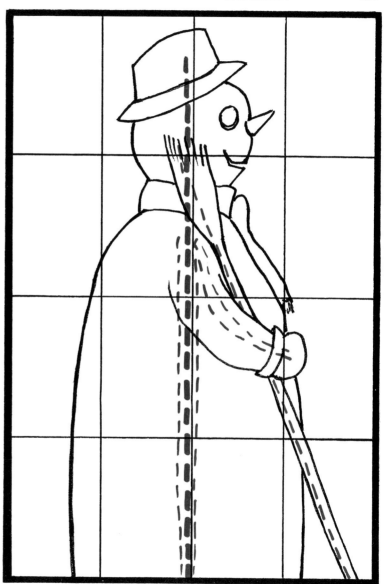

3:2

3:2

Father Christmas

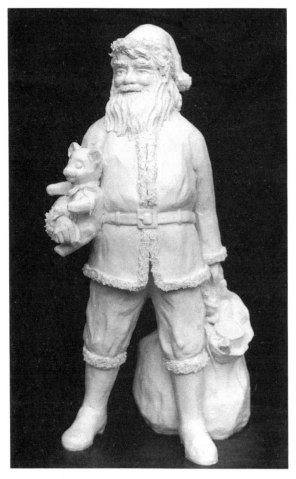

Santa is a suitable model only in the Christmas season; come 26 December and he is out of place, so make him early enough to take full advantage of the full festive season leading up to Christmas Day.

The model is a very solid construction based on a tripod frame. Rods support each leg and a third comes through the sack of toys and up the arm to be attached to the main body rods at shoulder level. A thinner wire is brought down from the shoulder to support the other arm which holds the teddy bear.

The face, probably the hardest feature to master at any time, is relatively easy in this case because of Santa's bushy beard, thick eyebrows and thick wavy hair, which conveniently cover most of his face as well as his neck and chin.

The mouth need only be suggested in the gap between the beard and the moustache, and the eyes, though the most difficult feature, are comparatively easy because Santa's old face may be allowed to have plenty of interesting wrinkles.

Use the point of a satay stick to get the effect of the fur trim on the coat and boots. The toys in Santa's sack can be made as simple or as complicated as you like.

This is a good model for mastering the basic technique of colouring margarine as a striking effect can be achieved by simply adding a red jacket, red trousers, and a red hat with a natural trim, and a black belt and boots.

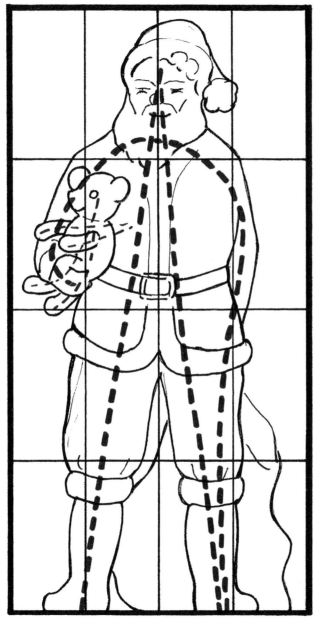

2:1

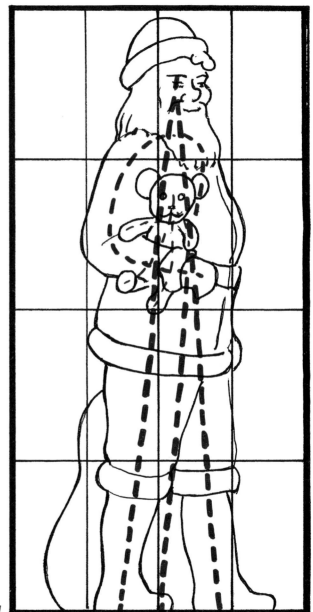

2:1

Girl with a basket

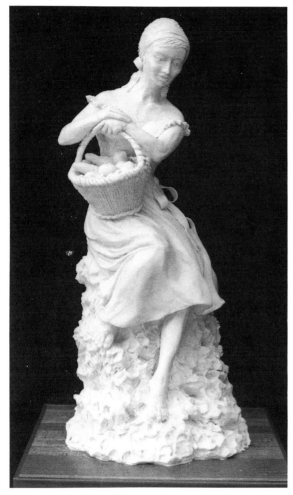

This model of a barefoot peasant girl resting on a rock with a basket of bread and fruit brought for the workers in the field is ideal for almost any buffet table.

The main frame is a simple one, consisting of a single heavy rod extending from the base through the body. It is bent into a curve at the top to allow for the natural contours of the shoulders and the inclined head. Secondary support wires attached to the main frame reinforce the arms, the basket and the legs.

Use a large block of styrofoam as the base of this model, making sure that it is wide enough to be absolutely stable. The styrofoam, which will form the bulk of the rock as well as acting as the base for the model, will keep down the weight of the model and the cost because less margarine will be required.

We have given our model a sense of movement by giving the body a slight twist, with one leg higher on the rock, inclining the head, and slightly bending the shoulders.

The model has a number of interesting different textures: the rough rock contrasting with the girl's smooth skin, and the intricate weave of the basket, so different from the casual folds of the dress.

The most difficult feature to capture is the girl's pretty smiling face, and the whole effect will be lost if it is not achieved (see Section 8).

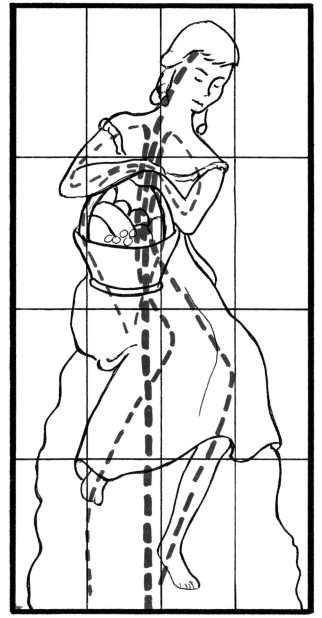

2:1

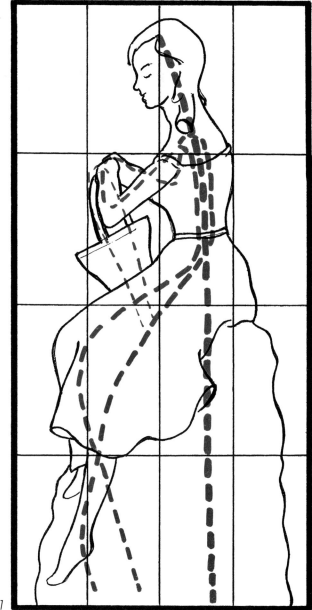

2:1

Neptune

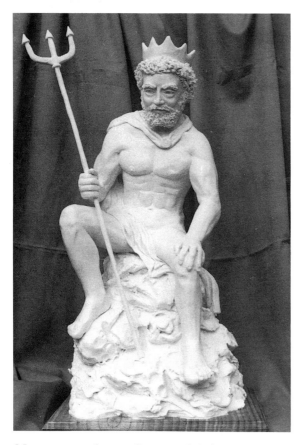

Neptune makes a fine model for a seafood restaurant or a seafood buffet. The King of the Seas is represented as a dominating figure, sitting on some rocks and surveying his domain. A powerful build and good boldly modelled muscles give him a proper sense of strength and authority.

A good deal of research is needed to get the proportions of the body and the placing of the muscles right, but the face is not as difficult as it looks because so much of it is covered by a bushy beard. Books for art students on figure drawing are useful for reference on the anatomical details, and we find that body building magazines are a great help with the muscles.

Neptune makes a very sturdy model which travels well. Its stability comes from the wide and solid base of rocks on which the figure sits.

The main frame consists of a single heavy metal rod bolted to a wooden base. It is bent in a slight forward curve and extends to the crown of the head.

Push a solid piece of styrofoam down to the bottom of the main rod to form the foundation of the rocks. Then cut the styrofoam into the rough shape of an irregular rock with a sharp knife. The thin wire framework which supports the arms and legs must be taped to the main frame, bent into the required shapes and firmly buried in the styrofoam base.

Use a very fine straight metal rod, secured in the base, to carry the trident which Neptune holds in his right hand.

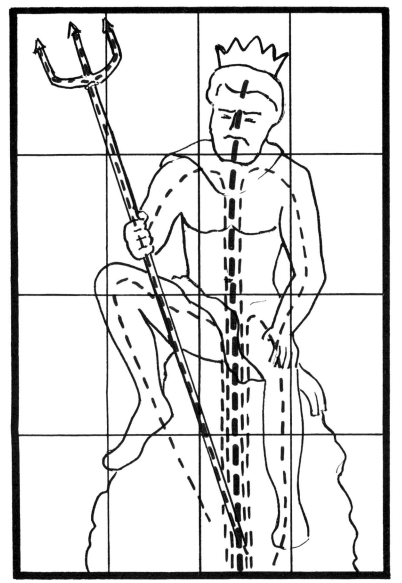

3:2

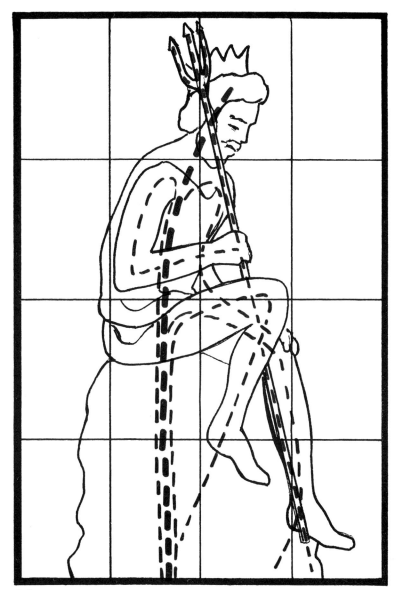

3:2

Tennis player

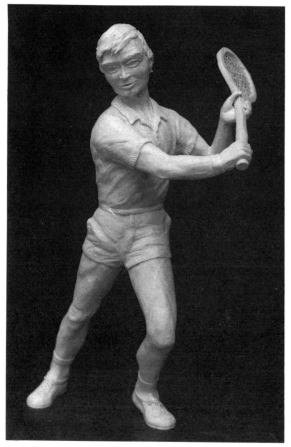

Models of sports players will attract the attention of people who themselves play the sport, so it is very important to make sure that you get the details right. Make sure that the posture is correct, and that the particular way of holding, catching, throwing, gripping and so on is correctly detailed.

The main frame for our model of a tennis player delivering a double-handed backhand consists of two rods, one in each leg, one longer than the other so that it extends to the head. A lighter-gauge wire is used as the support for the arms.

You have to be particularly careful to make sure the arms are the right length. When arms are bent in different directions it is easy to get one longer than the other, and this will be obvious in the finished model. Prevent this mistake by measuring the wire supports to make sure they are the same length for both arms, and measure from the shoulders to ensure that the arms are the right length in relation to the body,

The racket is made separately with fine wire and fixed to the main framework with florist's tape. Cover the frame of the racket with a layer of margarine. Use cotton for the strings, carefully wrapping it round the frame of the racket so that it sinks into the margarine at the frame and is criss-crossed across the face of the racket to form a cotton grid. Paint the grid with melted margarine and it will give the impression of a margarine racket.

An alternative method is to fill the centre of the racket with margarine and simply scratch in the grid pattern with a fine-pointed tool like a satay stick.

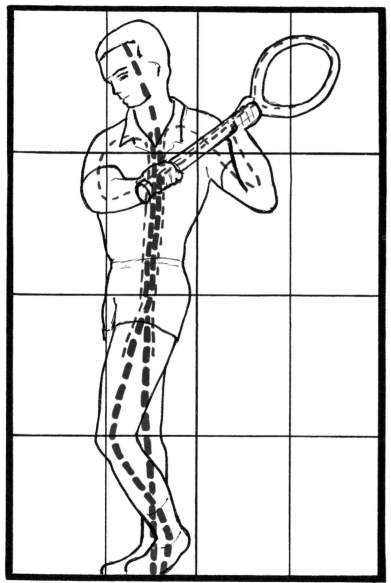

3:2

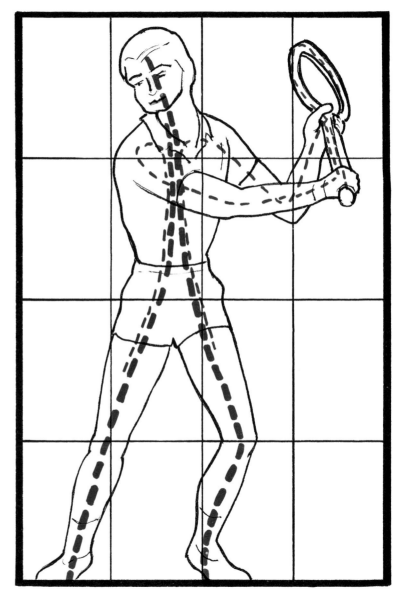

3:2

Horse and rider

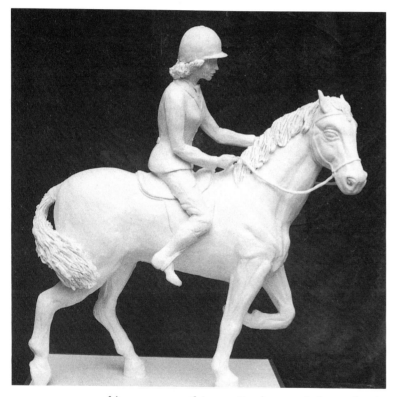

You can use this particular model as a basic type for other similar models involving a horse and rider—a show jumper, a cowgirl,

a jockey on a racehorse—all require only minor changes of stance and different clothes and equipment.

We suggest that you do not attempt to model a horse and rider until you have mastered both single figures such as the Girl with a Basket (page 132) and a lone horse like the Rearing Horse (page 126).

Note the way in which one of the horse's legs is raised to give the model movement and life.

The figure stands on a tripod of strong metal rods, which cross over each other for extra strength. The rod in one of the back legs of the horse continues through to support its raised front leg. A small quantity of styrofoam is used to take up the bulk of the horse's body.

Attach thinner wires to the main frame to support the horse's tail and the arms of the rider. The rider's leg should not need reinforcing with a frame but you can bury toothpicks in the horse's body to give it some extra stability.

To make the reins use very fine wire or cotton carefully covered with strands or ribbons of margarine. The bridle and the edging of the clothes are also made with thin strips of margarine which you can make by using a clay press or by the wet paper ribbon method. Both these techniques are explained in Section 6.

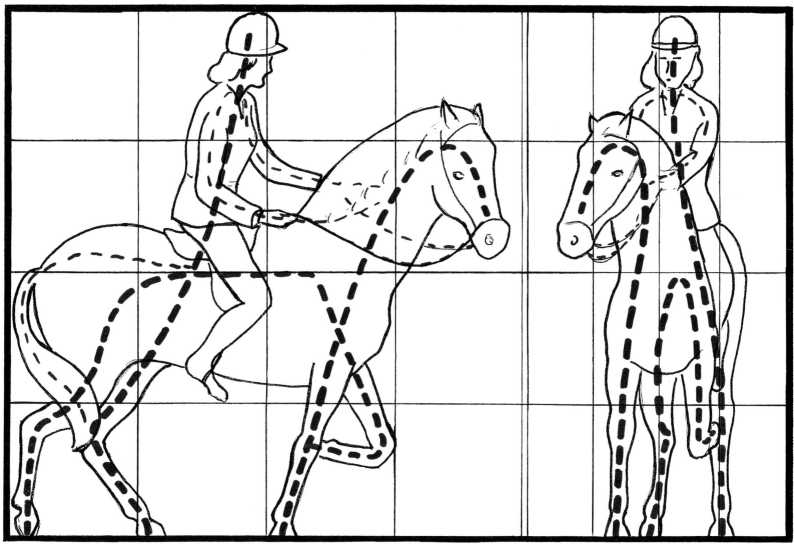

1:1 2:1

Swagman and his dog

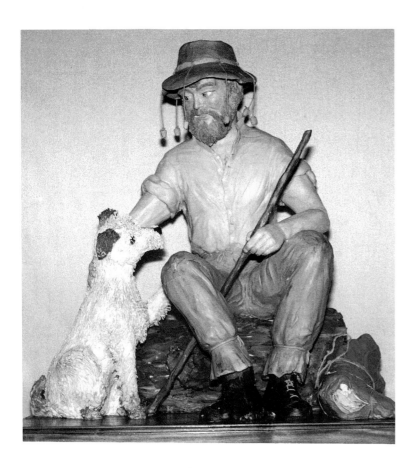

The combination of man and animal is always appealing when it portrays the bond and interaction between them. The swagman and his dog, folk heroes of the Australian bush, provide a good example of that kind of universal appeal, and show how indigenous folk characters can be used very effectively as the subjects for displays suitable, for example, for the foyer of an international hotel.

This is not a model for the inexperienced, and it should not be attempted until you have mastered plain and coloured animal and human figures. It is an exceptionally demanding model, and the variety of textures in, for example, the dog's hair, the swagman's clothes, and the log, combined with the subtle colours of the man's skin and the pastel shades of his clothes, calls for almost all the skills in margarine modelling.

The frame is relatively simple. One metal rod through the log and the man is the main support. From this rod secondary supports are attached for the dog, the arms and legs of the swagman, and his stick.

Work with plain margarine first to get the pose and the basic character correct before adding the colours and the textures.

The Swagman is illustrated in colour on page 10.

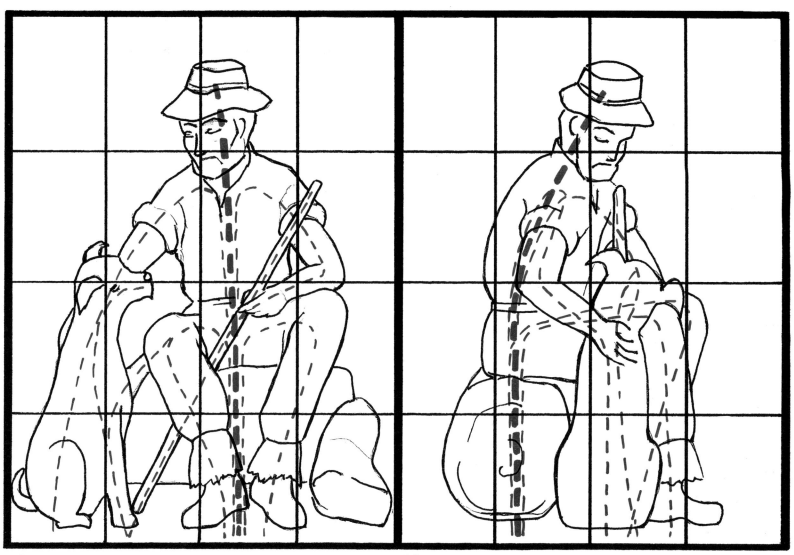

4:3

4:3

Australian Rules footballers

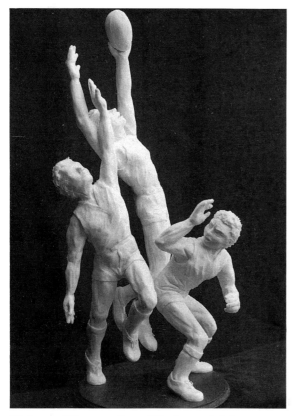

This exciting, action-filled model is an example of the way in which a team or body-contact sport can be used as the subject for a striking centrepiece. Models can be designed which catch the spirit of contest bet-

ween the players in such sports as basketball, American gridiron, rugby and soccer.

We have found that models of body-contact sports are usually more effective when made in plain margarine so that the viewer's attention is drawn to the action of the athletes' muscular bodies without being distracted by irrelevant colour.

Avoid identifying any particular teams by using a known logo unless you have been requested to do so by a client; this keeps the model neutral and allows everyone to imagine that it is their own team in the presentation.

Even though you portray the players without team identification make sure that you get the details of the players' dress correct, and that boots, shirts and so on are right for the particular sport.

If your model is to have a sense of excitement the facial expressions of the players must show the stress of the contest. Study action photographs to see how open mouths, ruffled hair, wide-open eyes, or stern brows can convey the strain on the faces of competing athletes.

The model should have a winning element and a losing element; one player should be winning the ball from the other. This appeals to clients who like to identify themselves or their team with the winner.

If you are designing your own model of

competing sportsmen (or women) you will find that it helps to make small models first. Make the figures roughly from margarine and use them to work out the different actions and combinations which best capture the spirit of the sport. When you have a miniature model which pleases you use it to plan the design and the frame for your full-sized display model.

The framework for a model of this kind is, of course, quite complex. The arrangement in our example uses a standard tripod design to give the model stability. Note how the figures are interconnected to support each other. Use rods as thick as the design will allow for the main supports to make the model as sturdy as possible. But, no matter how well constructed the frame is, models like this do not travel well because their height makes them relatively unstable.

With particularly complicated frames it is sometimes worthwhile to make a full-size mock-up in thin wire. This will give you a better understanding of the frame and help you to bend the thicker rods to the correct angles. The secondary framework is attached firmly to the main rods with florist's tape and the whole frame is taped thoroughly to disguise the metal as there is only a thin covering of margarine in many places.

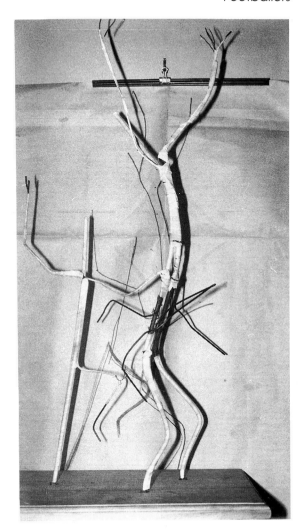

The frame covered with florist's tape

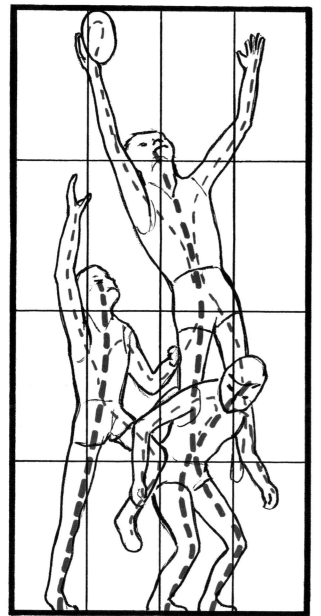

2:1

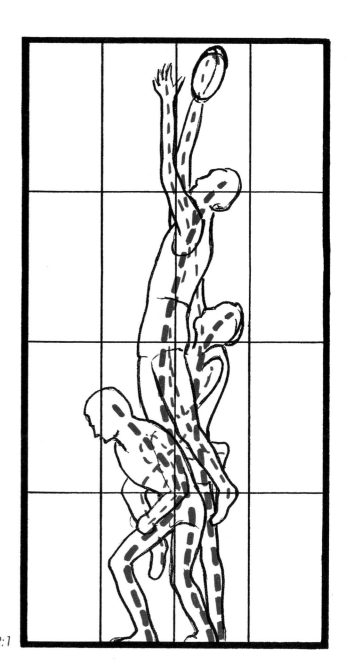

2:1

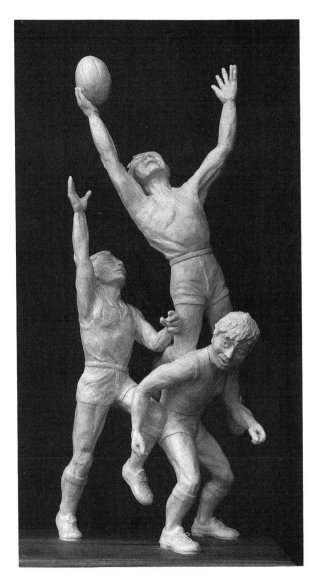
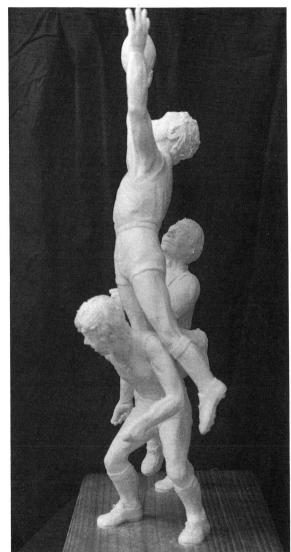

Tools and materials

Bolt cutters
A good heavy-duty cutter suitable for use with mild steel rods.

Butcher's paper
Used for full-sized designs.

Cheese slicers
For taking thin slices of margarine off wedges cut to a desired shape.

Clay press or clay gun
Produces a ribbon of margarine in a variety of shapes.
Recommended type: the Kemper Klaygun, available from Kemper Tools, P.O. 696, Chino, California 91710, U.S.A.

Colours
Oil soluble food colour, or food colour lakes.
Recommended type: Williams Food Colour Lakes.
Available from:
Australia: Robert Bryce, 145-7 Glenlyon Rd., Brunswick, Vic. 3056.
New Zealand: Food Tech Ingredients, Manukau City, Auckland.
United Kingdom: Greville House, Hibernia Rd., Hounslow, Middlesex. TW3 3RX.
United States, Canada and Japan: Address as for U.K.

Containers, glass or plastic
For moulding plaster bases.

Cotton buds
For finishing details.

Counter-sinking drill
For counter-sinking nuts in bases.

Cutters
Aspic, biscuit, and pastry cutters to make a range of fancy shapes.

Dowel
For constructing wooden frames.

Drawing paper or kitchen paper
For plans.

Drill and bit
For drilling holes to fit rods in wooden bases.

Edging tape
Plastic tape for edging chipboard bases.

Estapol or polyurethane finish
For glazing and protecting wooden bases.

Florist's tape
For fixing the secondary framework.
Recommended type: Parafilm
Available from florists or American Can Company Floral Products, Greenwich, Connecticut 06830, U.S.A.

Florist's wire
For subsidiary fine framework.

Garlic crushers
For making fine strands of margarine.
Glue
Wood glue for fixing dowels in wooden bases.
Greaseproof paper
For reinforcing thin strips of margarine in capes, ribbons, sails, etc.
Icing set
For making long strips and lengths of maragarine in a variety of shapes.
Knives
Kitchen knives of various shapes, sizes and edges.
Margarine (pastry)
High melting, hard plastic consistency. Recommended types:
Australia and New Zealand: Pastrex (E.O.I. Pty Ltd., Marrickville, NSW).
Japan: Bakewell (Nippon Lever KK, Tokyo),
United Kingdom: Flex (Craigmillar, Burgess Hill, West Sussex),
United States and Canada: Golden Covo Roll-in (Monarch Fine Foods, Rexdale, Ontario).
Modelling tools
A basic clay modelling tool kit.
Nuts
To fit the screw-threaded ends of the mild steel rods.
Paints
For bases.

Paper towels
For making decorative shapes.
Parisienne cutters
Melon-ball cutters in different sizes to make holes or balls.
Pens and pencils
Coloured pens and pencils for drawing plans.
Plaster of Paris
For plaster bases.
Pliers
For cutting and shaping wire for frames.
Polystyrene block
For taking up the bulk in the model.
Satay sticks
For modelling.
Saw
To cut wooden bases and frames.
Spatulas and scrapers
Plastic kitchen tools for smoothing large areas.
Stain
Wood stain for bases.
Steel rods
Mild steel rods, bendable, and which can easily been given a thread using a stock-and-die cast.
Stock-and-die cast
For cutting threads on steel rods.
Styrofoam blocks
Used to provide light and relatively cheap bulk inside larger models.

Toothpicks

For intricate modelling work.

Tulle

For covering models to protect them from dust.

Vice

To hold metal rods while they are bent.

Washers

For use with nuts fixing rods to bases.

Wire

In various gauges for the secondary framework.

Wood

For bases.

Glossary

Aspic cutters
Small metal cutters used to cut decorative shapes, usually for chaudfroid decoration.

Canapés
Small pieces of bread or toast, or biscuits, etc., topped with appetizing foods, decorated and usually served before a formal dinner.

Canapés à la Russe
Canapés served on a doily-covered silver platter.

Centrepiece
An ornamental food decoration used in a conspicuous position on a platter, table or buffet to catch and please the diner's eye.

Chaudfroid
A tasty, thick, cooked sauce applied as a glossy coating to cold meats, fish and game, decorated, and given a final coat of aspic.

Chef de cuisine
The 'Head of the kitchen', the senior chef in charge of the preparation and presentation of all the food at an establishment.

Clay press
A pump-action tube and plunger with a variety of disks used by ceramic artists. Sometimes called a clay gun.

Display centrepiece
A large ornamental food decoration placed in the centre of a buffet, usually reflecting the theme of the occasion or the food on offer.

Estapol
Trade name for clear gloss wood finish (polyurethane).

Florist's tape
Very fine stem wrap plastic tape used by florists in the arrangement of flowers; parafilm.

Garlic crusher
A metal press used to crush cloves of garlic. Also called a garlic press.

Hors concours
Above competition. The title given to people who are invited to display at a salon culinaire but not to compete because they would inevitably win.

Icing set
A pump-action tube and plunger, with a variety of nozzles used by cake decorators.

Mise-en-place
Literally 'put in place'; the basic preparation of materials and the collection and arrangement of the required tools.

Mock-up

A full-size copy of the framework constructed from thin, easily-bent wire, used as a guide for the making of a heavier permanent frame.

Parisienne cutter

A baller, sometimes called a melon baller. A kitchen tool which scoops out round balls from fruit and vegetables.

Pastillage

Gum paste, used to make ornamental confectionery decorations.

Pièce de résistance

The main dish of a meal or the main decoration on the table.

Petits fours

Small fancy highly-decorated cakes, biscuits or sweets, served with the coffee at the end of a dinner.

Pièce montée

Decorative item or a display centrepiece.

Plaster of Paris

A fine white powder which when mixed with water sets hard.

Polystyrene

A light firm plastic foam often used as an insulating or protective packaging material.

Polyunsaturated

Containing many insoluble fat globules which do not remain in the body when eaten.

Pulled sugar

Sugar boiled hard and moulded to form baskets, flowers, etc. as a confectionery display.

Ravier

A small earthenware container.

Salon culinaire

An exhibition of the art of cookery, usually including competitions.

Scale grid

A grid drawn to fit over a small picture, sketch or design to assist the drawing of larger plans in the correct proportions.

Showpiece

A food decoration intended for display at a salon culinaire.

Smorgasbord

A buffet meal of various hot and cold foods displayed or presented in a pleasing manner.

Stock-and-die cast

A hand-held tool which cuts threads on a rod or a bolt to accept a nut; a die stock.

Styrofoam

A trade name for polystyrene.

Template

The final full size drawing of the model and frame which is used as a pattern or gauge during the bending of the frame.

Tulle

A fine silk or nylon net used in dressmaking.

Index

*References to illustrations are printed in **bold** type.*